Forgotten Drinks of COLONIAL NEW ENGLAND

FROM FLIPS & RATTLE-SKULLS TO
SWITCHEL & SPRUCE BEER

CORIN HIRSCH

AMERICAN PALATE

Published by American Palate
A Division of The History Press
Charleston, SC 29403
www.historypress.net

First published 2014

ISBN 978.1.62619.249.2

Library of Congress Cataloging-in-Publication Data

Hirsch, Corin.
Forgotten drinks of colonial New England : from flips and rattle-skulls to switchel and
spruce beer / Corin Hirsch.
pages cm
Summary: "Discover the intoxicating history of the drinks that were a part of life in
Colonial New England but have since been lost to time"-- Provided by publisher.
Summary: "A survey of lost drinks from New England's colonial era, as well as recipes to
bring them back to life"-- Provided by publisher.
ISBN 978-1-54020-922-1
1. Beverages--New England--History. 2. Drinking behavior--New England--History. I.
Title.
TX815.H54 2014
641.20974--dc23
2013050303

CONTENTS

CONTENTS

Introduction

THOROUGHLY FOXED
AND FUDDLED

*D*id they really drink *that* much?"

I'm in a Vermont café with a friend, and a woman at the nearest table has overheard our talk about the epic drinking of colonial New Englanders—mugs of cider at breakfast, 11:00 a.m. drams of rum, Mimbos and Rattle-Skulls and flips knocked back one after the other in an alarming stream.

"Well, yeah, they drank quite a bit," I tell her, taking a sip of the lone pint I'll drink with that night's dinner. Our Yankee forebears would probably blink in disbelief at the relative timidity of that evening's victuals, but between us and them lay a centuries-long sea of temperance and Prohibition that drastically altered drinking habits. The nightlife districts of Boston, Portland and Providence may still host plenty of benders, but even Don Draper had nothing on early New Englanders, who could probably down four tankards of beer for every martini and follow it up with three mugs of flip and a bilberry dram to boot.

During that meal, I was nearing the end of a frenetic, blurry four months researching Stone-Fences, rum trading routes and Madeira punches. Even though I write about beverages as a food writer at Vermont newspaper *Seven Days*, I hadn't considered taking a plunge into colonial drinks until a note from an editor from The History Press unlocked some ideas. I proposed an uberlocal history book that fit its niche: a book on the

colonial-era beverages of New England. A chapter about rum, another about cider and some fleshing out of colonial tavern life.

What I hadn't realized was that European settlers practically swam in a sea of booze from breakfast 'til bedtime. Whether they were working, weeding, writing, selling goods, getting married or even dying, they drank so heartily that their lawmakers (who sometimes worked under the influence) constantly passed laws to regulate tavern practices, drink prices and what people drank—including how much, when and where: No drinking after nine o'clock. No drinking on Sunday. No drinking in the same room as your husband or your apprentice. Those laws rarely altered colonial residents' bent for the drink, however. Beer, cider, brandy and spirits flowed like water—*instead* of water, in most cases—and the day didn't begin until after a shot of bitters or stiffner of hard cider. A deal wasn't a deal unless sealed with a dram of rum, and the Declaration of Independence was written by a Founding Father sipping on Madeira, the choice tipple of the upper crust.

"Why didn't I learn that in school?" asked the woman, who had a mug of tea in her hand. My theory: who wants to tell a room full of children that their great-great-great-times-ten-grandfather didn't pick up a hoe unless he was totted up with "cyder" or that he may have had a liver the size of a grapefruit? That those early pious Puritans sipped beer and wine as part of their day-to-day? That the gentlemen of early New England were gravely concerned about liberty and fairness but also perpetually focused on the where and when of their next whetter—and those drinks, in turn, helped fuel and foment revolution.

Not all early Americans were comfortable with the prevailing ethos. I wrote some of this book in the library of Dartmouth College, whose 1769 charter notes that "no taverner of retailer should be licensed within three miles of the College." By 1778, college president Eleazor Wheelock was sending alarmed letters to New Hampshire's governor about a particular "disorderly" tavern across the street from the college that was soon joined by several more. Inside one, fellow students were discovered dancing on a table at 11:00 a.m., wine bottles in hand. The president was not pleased. Neither were scores of men before and after him, from parsons Increase and Cotton Mather to Dr. Benjamin Rush, whose late eighteenth-century writings on the corrosiveness of drink eventually helped birth the temperance movement.

This book is not intended to be scholarly—instead, it's a romp through colonial drinks, their origins and how they're made and blended. Some of these were the earliest artisanal American beverages. Honey became mead and metheglin. Pumpkins, spruce branches and herbs became ale and beer. Apples became cider and brandy, as did pears. Raspberries, blueberries and blackberries became wine. Vinegar flavored switchel. Drinks such as imported Madeira and sherry lubricated men who plotted the whys and wherefores of independence. Pilgrims, farmers, builders and adventurers sometimes bonded over punch bowls or pitchers of flip, drinks that softened the edges of a hardscrabble life of harsh Puritan mores and the frigid wildness of their New World.

Due to a dearth of historical material, the text occasionally crosses the temporal and spatial boundaries. Some of the drinks listed in Part 4—such as Mimbos, Ratafia, sangaree and slings—were more popular in the mid-Atlantic and the South than in New England. Some, such as whiskey, took their place at the bar after the colonies had become a new nation and so weren't really "colonial" per se.

In the last few years, cocktail menus from Maine to Rhode Island have been sprouting punches, cobblers and switchel, drinks that reach through time to put us sensually in touch with the day-to-day life of our ancestors. The idea that we can "taste" another era through re-creating its food and drink is thrilling.

Part 1

WHY THEY DRANK

Billings is at hoe. The Kitchen Folk say he is steady. A terrible drunken distracted Week he has made of the last. A Beast associating with the worst Beasts in the Neighborhood. Drunk with John Copeland, Seth Bass &c. Hurried as if possessed, like Robert the Coachman, or Turner the Stocking Weaver. Running to all the Shops and private Houses swilling Brandy, Wine and Cyder in quantities enough to destroy him. If the Ancients drank Wine as our People drink rum and Cyder it is no wonder We read of so many possessed with Devils.
—John Adams, July 18, 1796

*B*rutal. Barbarous. Deadly. Those are the terms that some modern historians have used to describe the America of the early 1600s, and they clang against the sanitized picture painted for us in grade school— that Pilgrims shared joyous feasts with natives and forged tiny utopian villages along the coast, sowing the first seeds of freedom and liberty.

The earliest waves of travelers who spilled across the Atlantic from England, Sweden and the Netherlands in the early 1600s were often jumping from one filthy, hardscrabble existence to another. Some were laborers who had been scooped up by European merchant companies and shipped to the New World so that they might send back gold, oil, wine and silk. Others, of course, fled religious persecution, grinding poverty or both. Once the emigrants arrived, scores died of disease,

Back in England, people mostly drank ale and beer in lieu of water. William Hogarth, *Beer Street*, 1751. *Wikimedia Commons.*

hunger and exposure—including half of the passengers and crew of the *Mayflower*.

The typical colonial-era New Englander was young and poor, worked to the bone…and often tipsy. Hacking one's way through forests, worrying about native raids, eating tons of fish and preserved meat and spending

every Sunday inside a freezing meetinghouse could help build an epic thirst. Drinking was both a generations-old coping mechanism and a survival tactic: the first settlers brought with them a love of taverns and a suspicion of drinking water. Even the Puritans weren't above tippling; most of them packed barrels of cider and ale for their trips across the Atlantic and set up breweries and cider presses once they were settled.

From breakfast cider to afternoon beer to evening flips, toddies and glasses of Canary wine, alcohol lubricated almost every hour of every day. John Adams may have been troubled by drunken acquaintances possessed by "Devils," but for most of his life, even the statesman sipped a tankard of hard cider before he sat down for breakfast. It was a habit he picked up as a student at Harvard University, where cider and beer were served to students during their meals and the school ran its own brewery.

John Adams's daily routine probably wasn't that much different than most of his contemporaries', although the drinks would have varied slightly by class. From the mid-1600s on, a New England rota looked like this: At breakfast, wash down some brown bread and sliced cheese with a pewter tankard of hard cider, the equivalent of two pints of beer. Work didn't proceed far before a late-morning break, the equivalent of the British "elevenses," an occasion for a glass of beer or another of cider. Lunch necessitated more booze, as did the afternoon break, supper and evening socializing in the local ordinary (aka tavern). A birth? Drink. A wedding? Drink some more. A death in the neighborhood? The family of the deceased were expected to keep the mourners well saturated with beer and rum drinks. Court dates, legislative sessions and even the exchange of goods often took place in ordinaries, where it was common to "raise healths" to anyone from the barman to the king to the stranger who had just wandered in from the road. And when someone in the room began toasting healths, everyone was required to knock back what was in their glass before it was promptly refilled. Even children sipped ciderkin, a low-alcohol hard cider—and sometimes they sipped the stronger stuff. "I have frequently seen Fathers wake their child of a year old from a sound sleep to make it drink Rum, or Brandy," wrote one New Englander visiting the Carolinas in the early 1800s. By the time the Revolutionary War began, colonists older than fifteen each drank 3.7 gallons of spirits per year, the equivalent of roughly seven shots per day. By 1790, that figure had swelled to 5 gallons, in addition to 34 gallons of beer and 1 gallon of wine.

It's an exhausting statistic and one that deserves context. Since the Middle Ages, drinking water was eschewed in England and elsewhere in Europe as something that could make you very, very sick. In England, waterways teemed with parasites and bacteria borne of the unbridled disposal of sewage, blood, animal waste and food scraps into streets and rivers. Although a scientific grasp of those microorganisms was still a few centuries off, basic human instinct reigned. As early as 1388, the English Parliament passed a law to curtail dumping into the country's rivers. By the 1500s, anyone living along the Thames, the Severn or other waterways had enough sense not to drink the water, lest they begin to tremble with fever and cramps or crumple into a dying heap. Instead, people hydrated themselves with fermented and distilled drinks such as ale, beer and, later, gin, all of which *didn't* make one dangerously ill and were believed to fortify the body with nutrients, minerals and manna.

English emigrants carted those beliefs with them to the New World with their barrels of beer, apple seeds and sacks of grain for malting. They were in for a surprise, as the blindingly fresh rivers and streams in the colonies restored their faith in drinking water. After the first Pilgrims set foot on land near Plymouth Rock and sat down to drink water from a stream, George Winslow gushed, "About ten o'clock we came into a deep valley, full of brush, wood-gaile, and long grass, through which we found little paths or tracks, and there we saw a deer, and found springs of fresh water, of which we were heartily glad, and sat us down and drunk our first New England water with as much delight as ever we drunk drink in all our lives." Captain Roger Clapp, who helped settle Dorchester, Massachusetts, in the mid-1600s, noted in his memoir that even though he and others went without bread—living on clams, mussels, fish, "Indian corn from Virginia," roasted goat and occasional provisions from Europe—they had a bounty of fresh water. "It was not accounted a strange thing in those days to drink water," he wrote, conscious of how alien that might sound back home.

Another more troublesome English habit trailed the emigrants to the New World: a lack of safe sanitation. People dumped chamber pots and scraps into nearby waterways and, within a few decades of arrival, had polluted water sources in the Virginia colonies and, later, Massachusetts. With only a nascent grasp of what caused disease and a lack of medicine, early Americans battled scores of viruses and bacterial diseases: smallpox, dengue fever, influenza and conditions with awful names such

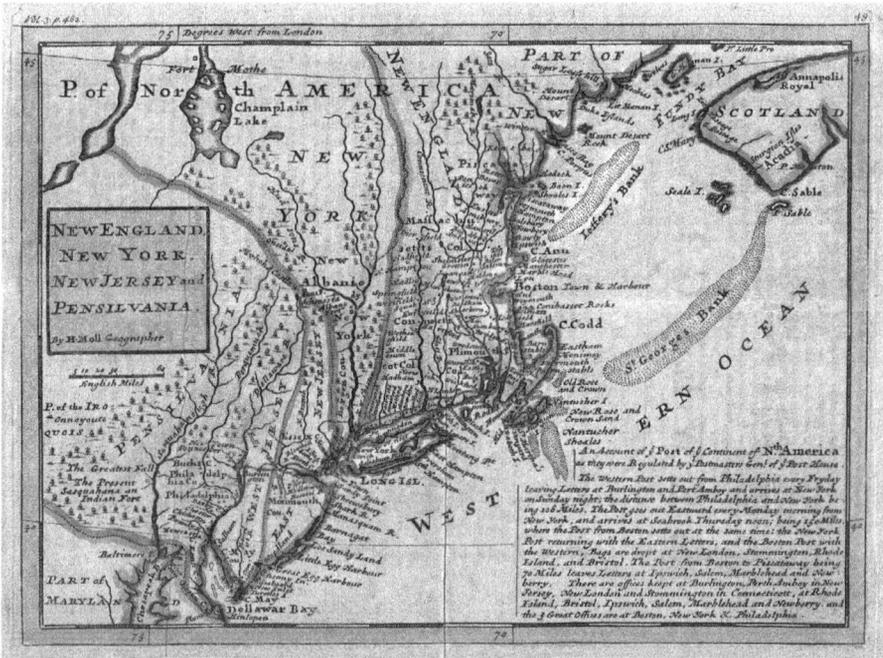

Moll Map of New York, New England, and Pennsylvania (first postal map of New England), 1729. *By Herman Moll, Geographer (Thos. and John Bowles, London), 1729, accessed from Wikimedia Commons.*

as black vomit and lockjaw. Infants died with regularity. The average life expectancy in the seventeenth-century colonies was just twenty-five years, although that figure is skewed by high levels of infant mortality.

The love affair with fresh New England water didn't erase the new settlers' thirst for drink. Brewing was a staple of life in England and the Netherlands, and the public houses where beer was sipped were nexus of community life. Many arrived with stores of beer or the starts of hops and grains and, at first, began drinking their own beer, which eventually was made with anything they could find on hand, from pumpkins to persimmons. (The first beer from England arrived in the Virginia colony in 1607.) Even as they eked out an existence in a harsh climate, they still had the wherewithal to erect taverns and brewhouses. They planted apple trees and, within a few years, were nurturing a cider culture. Wealthier colonists brought in bottles of Madeira and wine; by the late 1600s, rum was flooding New England from both the West Indies and the distilleries

that dotted the coast. A few decades after the first rough settlements at Plymouth and Boston, colonists had so many different ways for getting drunk, and did it so often, that their vernacular for the state was epic. Benjamin Franklin outlined these in a 1720s letter he wrote under his alias, Mrs. Silence Dogood:

> *They are seldom known to be* drunk, *though they are very often* boozy, cogey, tipsy, foxed, merry, mellow, fuddled, groatable, confoundedly cut, see two moons; *are* among the Philistines, in a very good humor, see the sun, *or*, the sun has shone upon them; *they* clip the King's English, *are* almost froze, feverish, in their altitudes, pretty well entered, *etc. In short, every day produces some new word or phrase which might be added to the vocabulary of the tipplers.*

As much as Americans swilled when they were still colonial subjects, it paled in comparison to what they drank *after* the war was over. Drinking surged in the early 1800s as corn became king and whiskey production exploded in places such as Pennsylvania and Kentucky. Even Vermont got into the fever, its citizens producing thousands of barrels of potato whiskey that they sold to Canadians to the north. Consumption of both spirits and cider surged, reaching a crescendo in about 1825 that hastened the temperance movement. "The thing has arrived to such a height, that we are actually threatened within, and becoming a nation of, drunkards," wrote a member of the Greene and Delaware Moral Society in 1815. A society steeped in booze had enough self-consciousness to know that the path it was stumbling down was not sustainable—and so it took to the other extreme, outlawing alcohol altogether. That American society could reach a nadir of drunkenness only a few decades before outlawing drinking altogether speaks to an all-or-naught national psychology.

Yet temperance was still a long way off in 1775, and it was inside smoky, fire-lit taverns where the Sons of Liberty plotted their revolution.

Part 2

WHERE THEY DRANK

'Tis true, drinking does not improve our faculties, but it enables us to use them; and therefore I conclude that much study and experience, and a little liquor, are of absolute necessity for some tempers, in order to make them accomplished orators.
—Mrs. Silence Dogood (Benjamin Franklin)

A drizzle had fallen throughout the day of April 18, 1775, muddying the roads and fields around Lexington, Massachusetts. By the time the sun had set, a west wind was blowing the clouds away. At about 9:00 p.m., an almost-full moon rose, casting a shimmer on the steeples, slate roofs and bare trees around Lexington Green.

At the Green's north end, the windows of Buckman Tavern glowed. The Buckman was Lexington's first licensed tavern, opened in 1693, and although it wasn't the only public house in the town—at least a dozen more did business here—its spot on the common made it a hangout for local militiamen. Buckman's taproom was just to the right of the front door, on the ground floor of the two-story house. That night, a fire crackled in the taproom's shoulder-high hearth, and the room reeked of smoke and wet wool. At tables on both sides of the fire, men played cards, puffed on clay pipes and swigged from mugs filled with warm, frothy flip. Scattered at their elbows were pages from the *Boston Gazette* and *Country Journal*, filled with indignant editorials over the latest affronts of Parliament and the troops stationed around the colony. The tavern's

proprietor, John Buckman, was a militiaman himself, and talk of war flowed as freely as the flip he poured from ceramic pitchers.

By 10:00 p.m. or so, most taverngoers had wandered home to their families and to bed—though not for long. At about midnight, a Boston blacksmith named Paul Revere galloped into town from the south. Revere had been knocking on doors along the way, rousing the residents of Menotomy and Lexington by shouting, "The Regulars are coming!" British troops were on their way from Boston, fifteen miles to the south, to snap up the weapons and gunpowder that the rebels had been amassing in Lexington and Concord. The farmers, lawyers, metal smiths and others who made up the Lexington Training Band pulled their waistcoats back on and returned hastily to the Green, muskets in hand. They milled there for a few hours, until about 2:00 a.m., when their commander told them they could return home but should remain on guard.

Instead, about eighty men tromped back into the Buckman Tavern. Behind the bar, John Buckman splashed rum into pitchers and topped them off with ale before plunging the fire's red-hot poker into each, whipping the drink into a froth. Three hours before the British troops would march onto the Green, some of the rebels who would confront

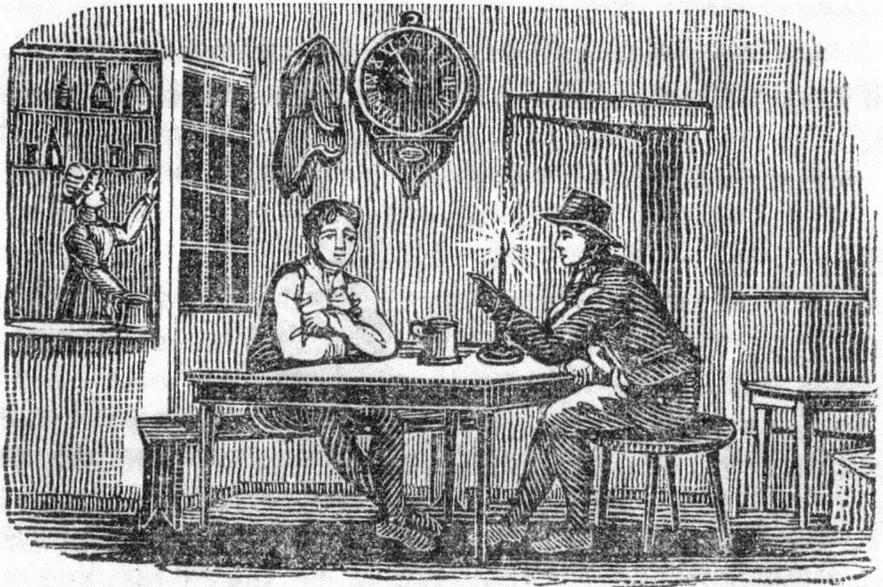

Two men drinking in a tavern from the American Tract Society (vol. 4, no. 102). *Collections of Old Sturbridge Village.*

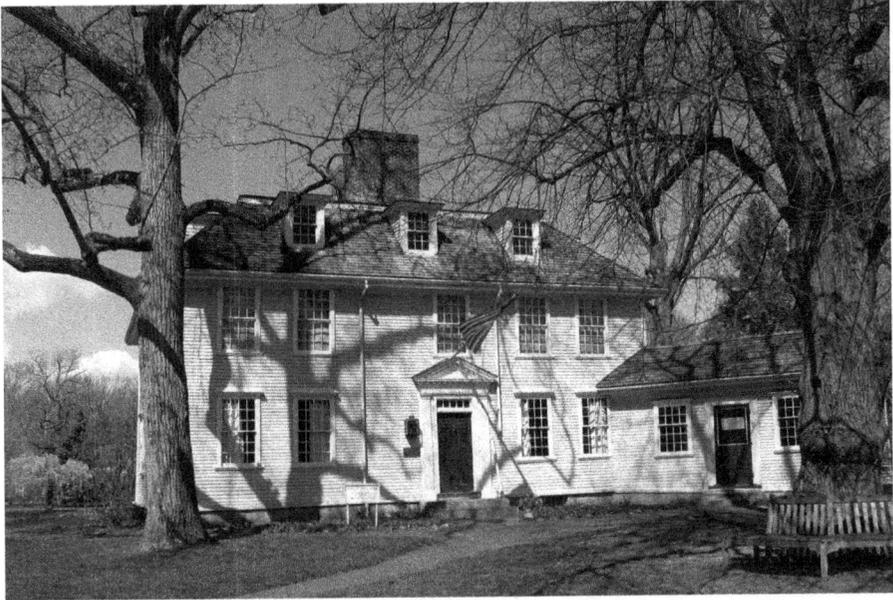

The Buckman Tavern in Lexington, Massachusetts, where militiamen supposedly knocked back flip in the hours before battle. *Wikimedia Commons.*

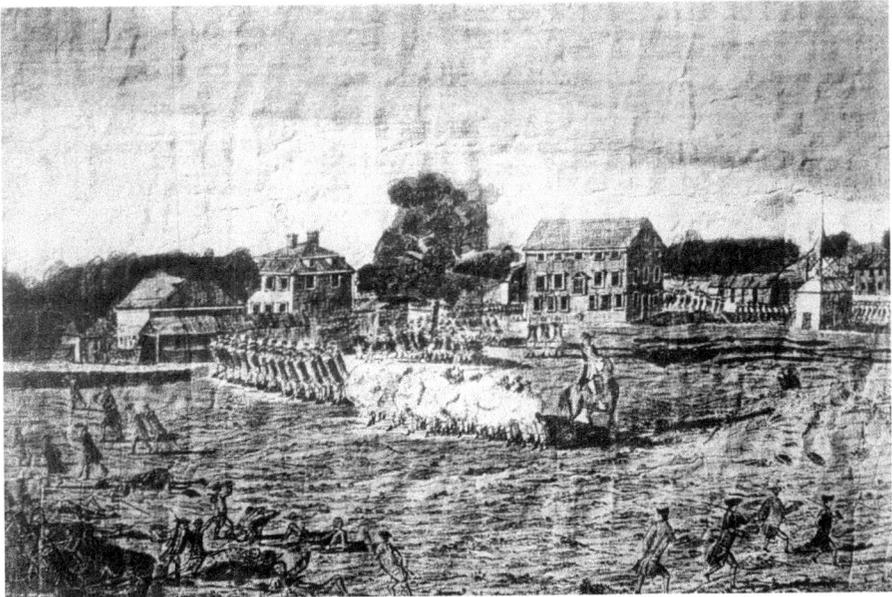

Battle of Lexington (with the Buckman Tavern in the background). Drawing from engraving by Amos Doolittle, a Connecticut militiaman. *Department of Defense Collection, accessed from Wikimedia Commons.*

them were sipping flips in the dead of night, fortifying themselves for the impending fight. When the cherry-red coats of the British appeared in Lexington just before dawn, the militiamen spilled back outside and lined the Green to face them. Someone fired a shot—it has never been clear who—and the Revolutionary War began. Eight of the militiamen would die in the next few moments, ten would be wounded and the Buckman Tavern's front door would be scarred evermore by a musket ball.

THE "SPIRITS" OF INDEPENDENCE

Pairing liquor with gunplay usually spells trouble, but booze played a key cultural and military role both leading up to and during the eight-year-long Revolutionary War. Plans for independence had unfurled for years over punch bowls, flips and tankards of cider served up in the hundreds of taverns throughout New England. The rebels who hurled crates of tea into the harbor during the Boston Tea Party had beforehand fortified themselves with rum and beer at a city tavern called the Green Dragon Inn. The Catamount Tavern in Bennington, Vermont, was a hangout for Vermont's wartime hell-raisers, the Green Mountain Boys. The commander in chief of the Continental army, George Washington, sipped rum and cider before battle, as did his troops and those of almost every other general and commander—at least when it was available. Soldiers were paid partially in rum to keep them fortified and relaxed. Thomas Jefferson drafted the Declaration of Independence in 1776 at a Philadelphia tavern called the Indian Queen with a glass of Madeira at hand. Roughly a year later, during a stormy summer day, Vermont's founders gathered at Elijah Wood's two-story, white clapboard tavern in the center of Windsor to sign that state's groundbreaking charter, the first that would abolish slavery among the thirteen states.

Rather than causing mayhem, though, colonial-era livers were well accustomed to copious amounts of alcohol; many of those benders took place in public houses such as the Buckman. For nearly one hundred years since the first shot was fired on Lexington's Battle Green, colonial courts considered public houses—then called ordinaries—to be such a

"A Good Story." *Library of Congress.*

cornerstone of community life that they were required by law in many towns and villages, with the most respected citizens usually appointed to run them.

The first colonial ordinaries sprang up at crossroads, ports and ferry landings shortly after European immigrants began spilling into New England. Maine's earliest tavern, the Seaside Inn in Kennebunkport, began its life in 1667 at one terminus of a ferry that took travelers across the Kennebunk River. Taverns were also built or constructed on the greens of New England towns and often near or next to the meetinghouse—the two would exist in uneasy but symbiotic proximity for centuries, one easing the hardships or sins of the other. Early taverns were sometimes recognizable via the line of horses tethered out front, a jug on a stick or a colorful, sometimes ornate sign that might depict an eagle, a trotting black horse, a heaping plate of oysters (Gordon's Inn in New London, Connecticut) or the wide-eyed head of a bull (for a 1760s tavern of the same name in East Windsor, Connecticut).

The Blue Anchor. The Indian Queen. The Green Dragon. The Liberty Tree Tavern. Conkey's Tavern. Bull Dog Tavern. The Old

Ordinary. Early ordinaries varied wildly in their names and respective comforts, but many were located in structures that looked remarkably similar: a plain, gable-roofed two-story house oriented around a central chimney and staircase. To one side might be a room where women could gather; on the other, a smoky, putrid taproom where men would gossip, legislate or conduct business as they sipped beer, cider, posset, sack, flip, brandy, Madeira, toddy or any of the mélange of drinks that colonial New Englanders had to choose from—often while smoking slender clay pipes.

It wasn't just the promise of alcohol that drew men inside or had courts scrambling to dole out more and more licenses for public houses. Taverns played pivotal roles in colonial New England culture as dynamic centers of community life, places where men could catch up on news, sell goods, write letters, read books or even litigate. In 1644, Connecticut made it mandatory for towns to keep a tavern; in 1656, the Massachusetts General Court decreed that every town should have a tavern or public house, the

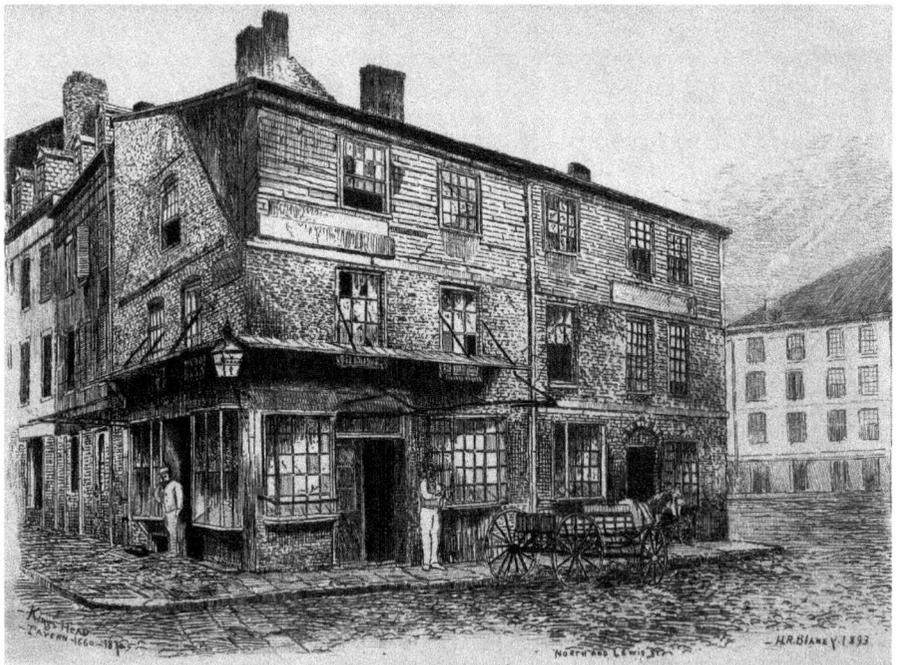

King's Head Tavern, 1660–1870, North End, Lewis Street, 1893. *Harvard Art Museums/ Fogg Museum.*

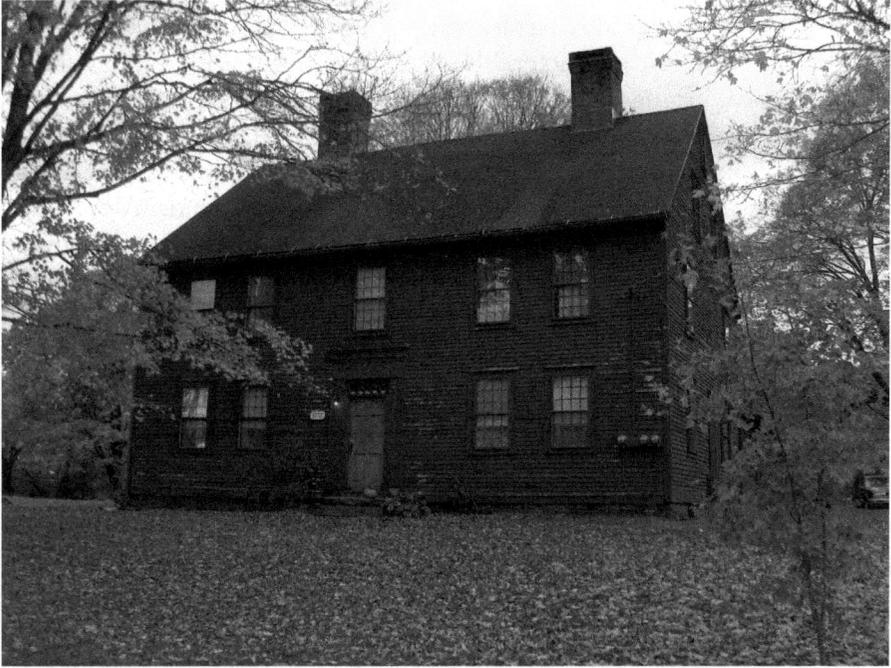

White's Tavern in Andover, Connecticut, built in 1773 but now occupied as a house. The tavern was associated with the march of Rochambeau's army in the Revolutionary War. *Photo by "Sphilbrick" on Wikimedia Commons.*

proprietors of which would have clean backgrounds and be chosen by local authorities. One New Hampshire historian wrote, "The long list of innholders or tavern keepers in Andover sounds remarkable, if one considers the size of the town." Ditto for Framingham, Massachusetts, which had six public houses in the 1770s for a population of just over 1,300 people.

Inside, these ordinaries could range from primitive to refined, but they were often small, hot and funky. For travelers riding from place to place, they were hostelries where one could find food, drink and a mattress on any journey longer than fifty miles—but the farther one traveled from the cities, the smaller, rougher, colder and more vermin-infested those taverns could become. "Foreign visitors…often complained about the cramped conditions of the relatively small American tavern," wrote historian Donna-Belle Garvin. Andover historian John Eastman noted that early

taverns required very little capital and that "the accommodations required were of the simplest character," built of logs and full of "pungent jest and ready wit." Pungent, indeed—although colonists splashed water on themselves every day, they bathed infrequently.

Public houses were stocked with both American and English newspapers, as well as an occasional writing desk where drinkers could write letters and complete transactions. Some early inns had beds right in the taproom, others in an adjacent or upstairs room, where there might also be a spacious function room for dances, weddings and Masonic lodge meetings. Taverns were often second only to meetinghouses in civic importance and served as courts in rural areas. If you had accused someone of, say, stealing your cow, sometimes you'd face them across a low-slung tavern table.

Until the late 1600s, most ordinaries lacked chairs; instead, wooden benches lined the walls, some facing low tables where a visitor could rest his drink. Boston's King's Arms Tavern had only four chairs in 1651 but two dozen benches, a detail that indirectly stresses the tightening of community and neighborly bonds.

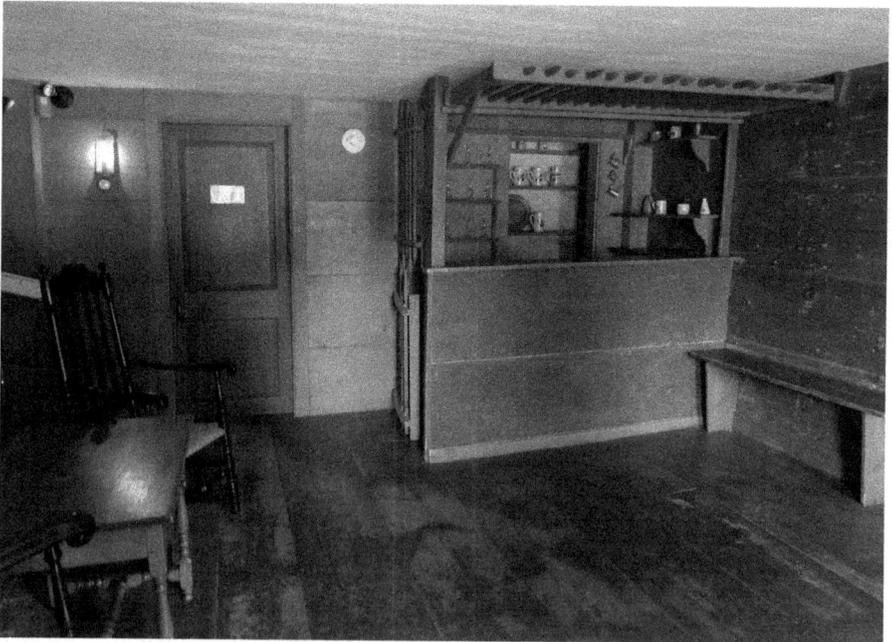

The corner taproom of Hall Tavern, originally built in 1760 in Charlemont, Massachusetts, but now part of historic Deerfield. *Author photo.*

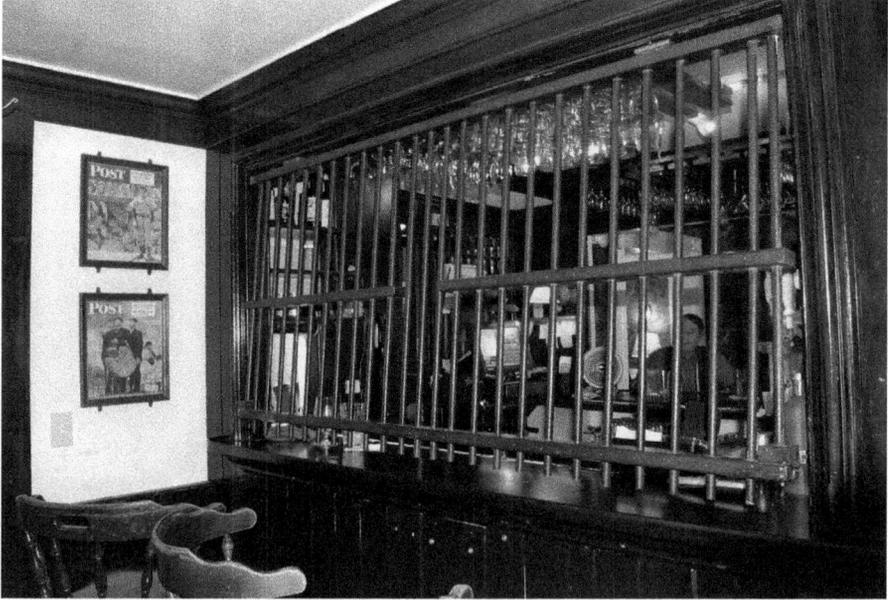

Spikes might be drawn down over a colonial bar at the end of the evening; this cage still exists inside the Colonial Inn in Concord, Massachusetts. *Author photo.*

When a man pushed through the door of a tavern (and it was usually a free white man; slaves, servants and women weren't welcome), he might state his name, profession and hometown aloud, as Benjamin Franklin did throughout his adult life. He could then order from a small corner bar that often resembled a closet or "dispensary," which often had a door of spiky wooden bars that could be drawn down at the end of the session.

Behind that bar, shelves were lined with cordial glasses, pewter and ceramic mugs, tankards and bottles of wine and brandy. A wooden cask might sit on a stand, filled with cider, beer, Madeira or rum that was tapped from a syphon near its base. The landscape of drink behind the bar depended on the period, the locale and the clientele. In the mid- to late 1600s, beer and ale filled most colonial vessels; as orchards matured, beer was gradually supplanted by hard cider. Brandy, Madeira and wine were more common in the urban (and more refined) public houses of Boston and New York. Rum was a truly egalitarian drink: once it began pouring into New England in the late 1600s, it filled the glasses of both

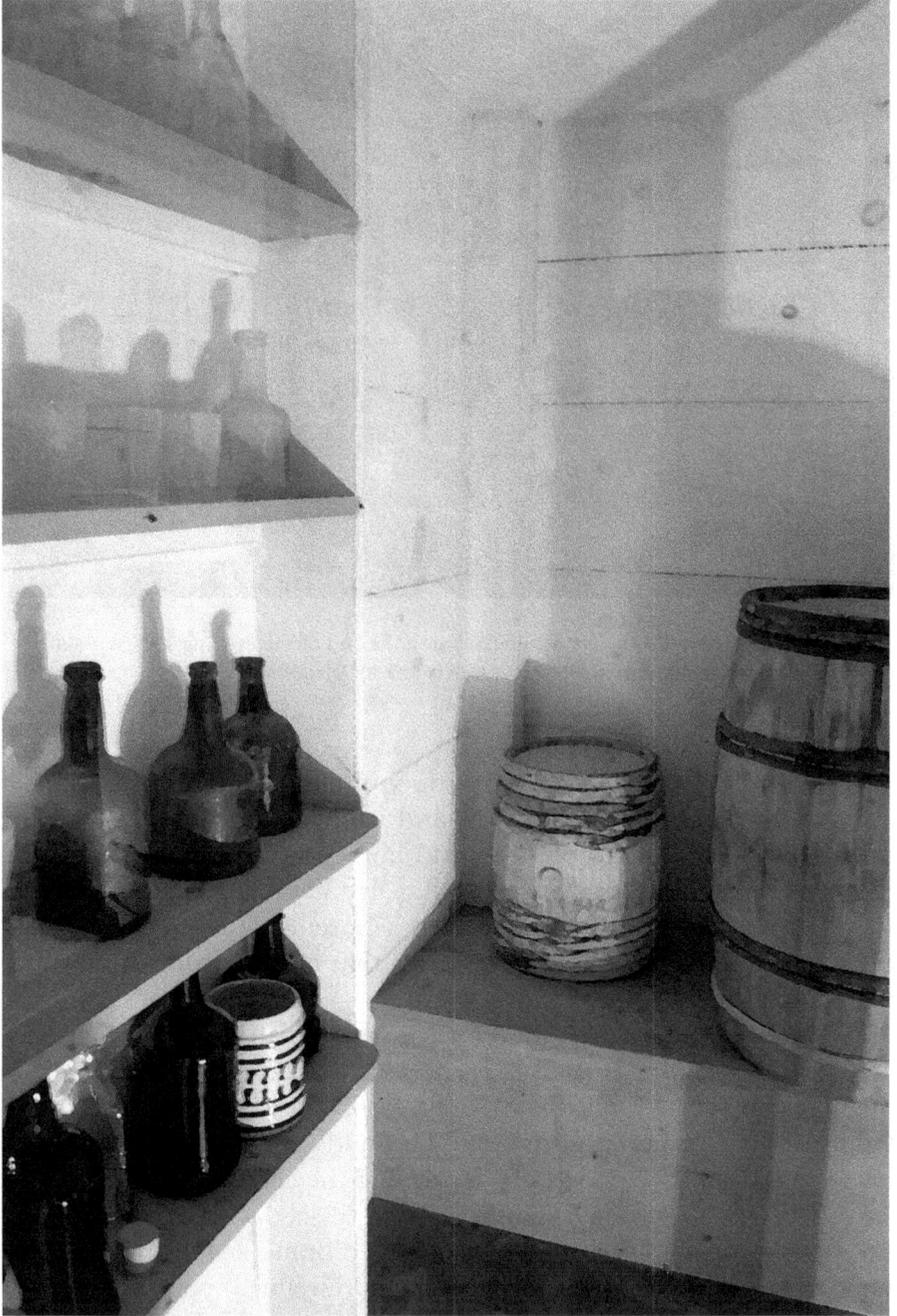

Tavern bottles photographed by the author at the Strawberry Banke Museum, Portsmouth, New Hampshire, September 2013.

ruffians and gentlemen, although the latter might take their rumbullion blended into a punch or toddy rather than straight.

Food was more of an ornament to drinking, but if the lady of the house was a decent cook, it could make or break the establishment's reputation. As one historian put it, "The tavern keeper whose wife, daughter or maid was a good cook, seldom found business dull." Whatever bubbled in the hearth or Dutch oven of the back kitchen was sometimes scrawled on a slate board, from breads and pastries to smoked ham or pigeon. Travelers might take their meal alongside the tavern keeper and his family. It was hearty stuff—Samuel Vaughan, an English merchant who traveled through America just after the war, ate "good strawberries" in one Pennsylvania public house and, in another, "Ham, bacon & fowl pigeon of one sort or another always to be had upon the road & often fresh meat or fish, dried Venison Indian or Wheaten bread, butter eggs milk, often cheese, drinks Rum, Brandy or Whiskey, resembling Gin."

A seaside tavern might serve up oysters, fried fish, boiled peas, apple pie, johnnycakes or an Indian pudding of cornmeal, eggs, cream and spices. Boston-style baked beans, a stew of beans sweetened with molasses and spiked with salted pork, were born on the tavern hearths of that city.

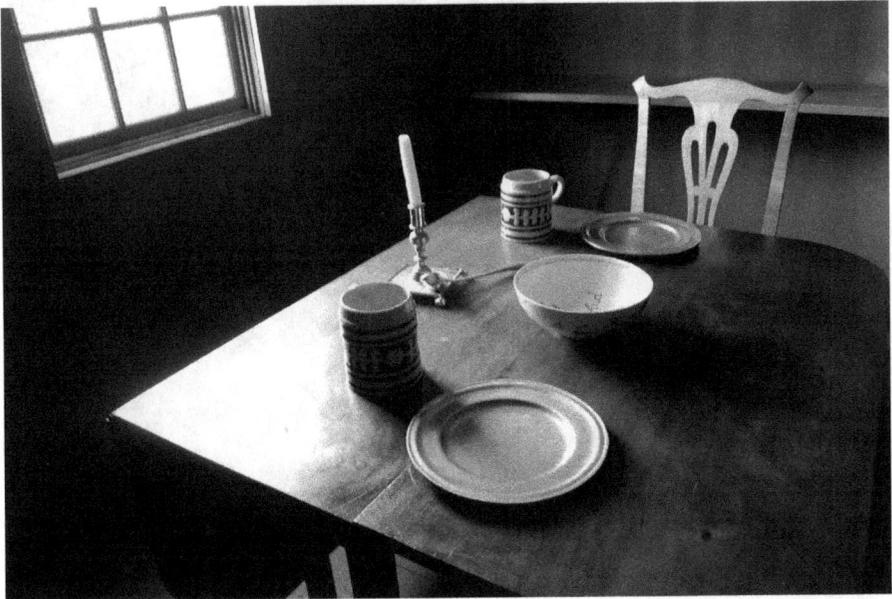

Whatever simmered on the hearth that particular day was what you were given to eat. Still life of a tavern table setting from Pitt Tavern. *Photo taken by the author at Strawbery Banke Museum, Portsmouth, New Hampshire.*

In the spring of 1774, the New London, Connecticut, a tavern owned by Thomas Allen in that same city, served "beef once, veal seven times, fowl and turkey five times, mutton twice, and lobsters, salmon, eels, oysters, duck, and other fish caught in nearby Long Island Sound at least once," according to historian Kym Rice. He had on hand stores of gammons— smoked ham or bacon—as well as smoked and pickled tongue and beef, salt pork, crackers, butter, coffee, apples and sugar. Meat, heavily salted for preservation, was the mainstay of the eighteenth-century diet. In addition, Allen regularly served bread and a potpourri of vegetables: potatoes, carrots, peas, beans, beets, onions, cabbages, turnips, squashes and cucumbers for pickling. He bought several types of English cheeses and imported lemons and limes for punch. In 1790, Allen ordered four tin plates "to Bake Gingerbread."

The celebrated French writer Jean Anthelme Brillat-Savarin spent a few gluttonous months crisscrossing New England after the war. At the tavern owned by Sam Fraunces in Lower Manhattan, the author of *The Physiology of Taste* feasted on duck, turkey, bear, venison and pigeon, plus "roast beef, turkey, vegetables, salad, fruit tart, cheese, and nuts, all

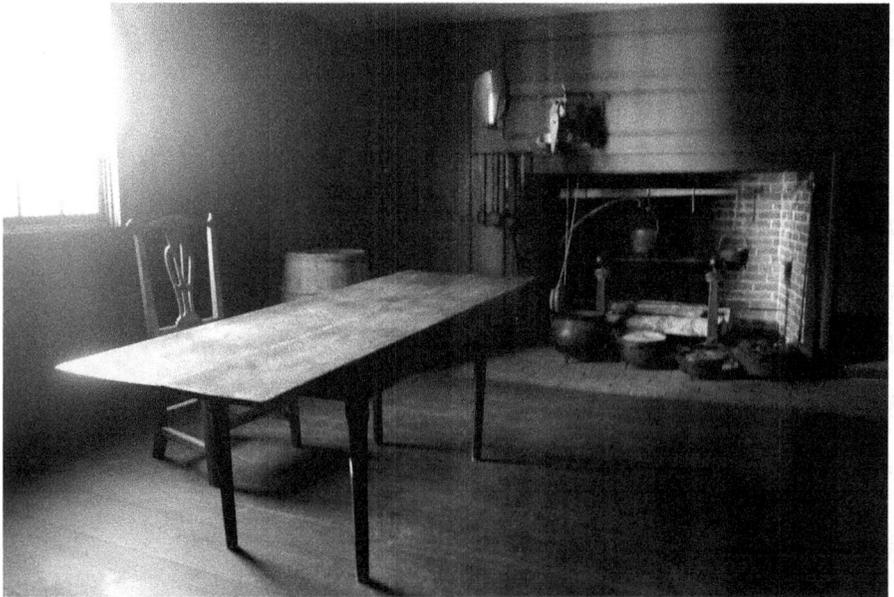

The hearth was the focal point of most colonial taprooms. Colonial tavern interior view from Pitt Tavern, built in 1766. *Photo taken by the author at Strawbery Banke Museum, Portsmouth, New Hampshire.*

accompanied by copious quantities of claret, Port, and Madeira, followed by rum, brandy, and whiskey."

New England tavern fare could be much less refined but still gut-stuffing. Some travelers broke up the journey from Boston to Salem at an ordinary called The Anchor, owned by Joseph Armitage. In its 1650s heyday, The Anchor served men such as Governor John Endecott "vitals, beare, and logen." Later, the tavern was renamed Blue Anchor by John Marshall, who continued stuffing his guests with heavy, simple New England food. "About two of the clock I reached Capt. Marshall's house which is half-way between Boston and Salem; here I staid to refresh nature with a pint of sack and a good fowl," wrote the English bookseller John Dunton in 1686. "Capt. Marshall is a hearty old gentleman, formerly one of Oliver's soldiers, upon which he very much values himself. He had all the history of the civil war at his fingers end and if we may believe him Oliver did hardly anything that was considerable without his assistance, and if I'd have staid as long as he'd have talked, he'd have spoiled my ramble at Salem."

THE FLUSH OF YOUTH

Drinking habits formed early. As previously mentioned, children sometimes sipped on a low-alcohol hard cider called ciderkin. At Harvard University, students were supplied with their own wooden plates and pewter mugs for 5:00 a.m. breakfasts of beer and bread. Later in the morning, their mugs would be filled with beer for a nosh of bacon, eggs and porridge and again in the afternoon for supper. In 1657, Harvard students drank 257 gallons of university-brewed beer.

Yet angst over youthful revelry persisted farther north in Hanover, New Hampshire, where the first godly president of Dartmouth College, Eleazor Wheelock, was perpetually troubled by the public houses that operated on the college's south edge. Two acres had been granted to a tavern owner named Captain Aaron Storrs, Wheelock's bookkeeper, in May 1771; inasmuch as Wheelock would have hoped that Storrs would be the only purveyor in town, the assembly in Portsmouth issued in 1772 another license to one John Payne, who was enthusiastic in his efforts

Initially, games were outlawed inside colonial taverns. A scene from Pitt Tavern.

to sell alcohol to Native Americans and students alike. As the years wore on, the college president became alarmed by Payne's trade and hoped that the state court would revoke his license when it came up for a two-year renewal. Not only was it reissued, but the court also offered a *third* license to a proprietor named Hill. Another tavern keeper, John Sargent, was given a license to open a tavern at the landing for the ferry that crossed the Connecticut River to Norwich, Vermont. Soon, Eleazor Wheelock's young students were surrounded by dens of inequity, much to his chagrin. Despite Storrs's upstanding reputation, even his public house wasn't without trouble. In 1773, Piermont resident Francis Fenton was fined for "profane cursing at the house of Aaron Storrs, Innholder in Hanover, in stating that he wished said Storrs damned."

The president sent pained letters to his chum Governor Wentworth, who assured Eleazor that "[s]uch extravagances of youth will happen, among numbers, in any society, nor can any be exported in this world; where the folly & passions of inexperienced young men, will not require correction."

Still, Eleazor Wheelock continued to dog Payne, who was brought to trial in April 1775 after a few students were observed at his establishment one morning at 9:00 a.m., drinking "some egg toddy"—one Michael Dugit, drunk on wine, stood on a table and then retched on a nearby bed.

PINTS AND PUNISHMENT

While communal drinking served to tighten the bonds among students, neighbors and families; bend the lines between classes; and fuel plans

for independence, the constant drinking and toasting to "healths" caused trouble even beyond Wheelock's. Although the Puritans who settled parts of New England weren't opposed to a daily glass of wine or beer—moderate drinking was thought to keep one healthy—obvious drunkenness seemed to trouble and preoccupy lawmakers. Samuel Sewall, a Massachusetts judge who zigzagged across the colony in the late 1600s and early 1700s, recalled this frustrating encounter in his diary from December 1714:

> *My neighbor Colson knocks at my door about nine P.M. or past to tell of disorders at the ordinary at the South End kept by Mr. Wallace. He desired me that I would accompany Mr. Bromfield and Constable Howard hither. It was 35 minutes past nine before Mr. Bromfield came, then we went, took Aeneas Salter with us. Found much company. They refused to go away. Said was there to drink the Queen's health and had many other healths to drink. Called for more drink and drank to me. I took notice of the affront, to them. Said they must and would stay upon that solemn occasion. Mr. Netmaker drank the Queen's health to me. I told him I drank none; on that he ceased. Mr. Brinley put on his hat to affront me. I made him take it off. I threatened to send some of them to prison. They said they could but pay their fine and doing that might stay. I told them if they had not a care they would be guilty of a riot. Mr. Bromfield spake of raising a number of men to quell them, and was in some heat ready to run into the street. But I did not like that. Not having pen and ink I went to take their names with my pencil and not knowing how to spell their names they themselves of their own accord writ them. At last I addressed myself to Mr. Banister. I told him he had been longest an inhabitant and freeholder and I expected he would set a good example by departing thence. Upon this he invited them to his own house, and away they went. And we went after them away.*

Yet Sewall also enjoyed the occasional or more-than-occasional tipple, recording more than a dozen drinks in his diary, from the "Kans of ale" to wine, beer, cider, Madeira, brandy and punch. He exemplified the uneasy, ever-shifting balance between colonists' embrace of habitual drinking and the fear that it might unravel the fabric of their nascent society. From the mid-1600s on, the courts, assemblies, legislatures and

governors of the thirteen colonies attempted to control consumption by regulating virtually every aspect of drinking. The first Massachusetts Bay Colony law pertaining to drink was passed in 1633, and it dictated that "no person should sell wine or strong water without having first obtained permission from the governor or his deputy to do so." That same law forbade the selling of "strong water" to "Indians" to check their wildness. Colonists had been using alcohol to gain the upper hand in negotiations with Native Americans, a sordid practice that unfolded in all of the colonies with disastrous effects.

The colony's magistrates also restricted drinking times to "ye space of halfe and hour" per day in 1645 (with a penalty of six shillings); how late a tavern might serve (often nine o'clock); who exactly was permitted inside an inn (at first, they were intended solely for travelers); and the quantities people might drink, such as "no more than a half-pint of wine." In Ipswich, Massachusetts, in 1662, as elsewhere, tavern keepers were required to record each drink that their customers consumed, as well as its cost; this gave rise to oblong tavern ledgers covered in elegantly rendered records. Licensed tavern keepers were also compelled "not to sell by retail to any but men of family and good repute, not to sell any after sun sett."

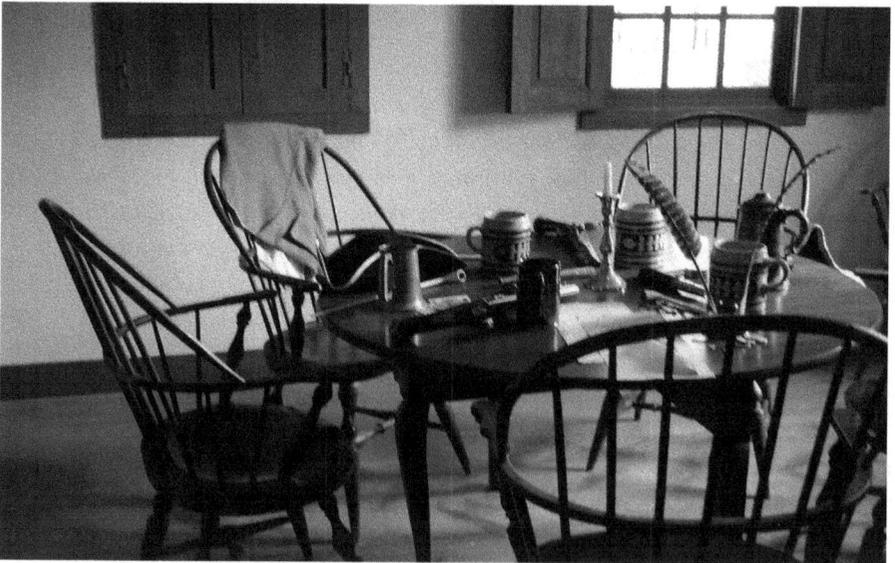

Still life of a tavern table from Pitt Tavern, built in 1766. *Photo taken by the author at Strawbery Banke Museum, Portsmouth, New Hampshire.*

A MORAL AND PHYSICAL THERMOMETER.

A scale of the progress of Temperance and Intemperance.—Liquors with effects in their usual order.

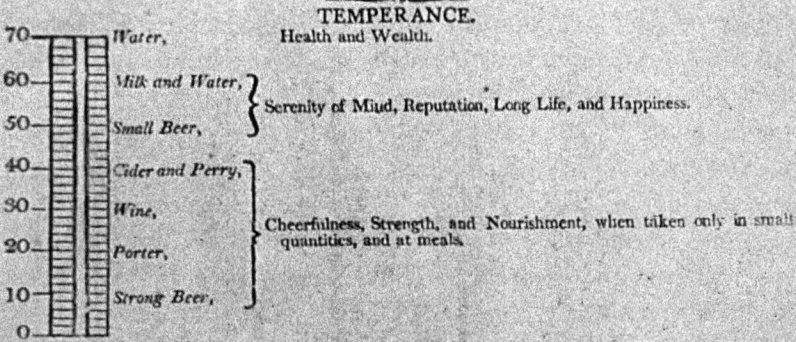

TEMPERANCE.

			Health and Wealth.
70	Water,		Health and Wealth.
60	Milk and Water,	}	Serenity of Mind, Reputation, Long Life, and Happiness.
50	Small Beer,		
40	Cider and Perry,	}	
30	Wine,		Cheerfulness, Strength, and Nourishment, when taken only in small quantities, and at meals.
20	Porter,		
10	Strong Beer,	}	
0			

INTEMPERANCE.

		VICES.	DISEASES.	PUNISH- MENTS.
0				
10	Punch,	Idleness,	Sickness,	Debt.
20	Toddy and Egg Rum,	Gaming, Peevishness, Quarrelling,	Tremors of the hands in the morning, puking, bloatedness	Jail.
30	Grog—Brandy and Water,	Fighting, Horse Racing,	Inflamed eyes, red nose and face,	Black Eyes, and Rags.
40	Flip and Shrub,	Lying and Swearing,	Sore and swelled legs, jaundice,	Hospital or Poor House.
50	Bitters infused in Spirits and Cordials.	Stealing and Swindling,	Pains in the hands, burning in the hands, and feet,	Bridewell.
60	Drams of Gin, Brandy, and Rum, in the morning,	Perjury,	Dropsy, Epilepsy,	State Prison.
70	The same morning and evening, The same during day and night,	Burglary, Murder,	Melancholy, palsy, appoplexy Madness, Depair,	do for life. GALLOWS.

A "Moral and Physical Thermometer." *U.S. National Library of Medicine, History of Medicine Division.*

Early laws could be unforgiving and Puritan-esque when it came public drunkenness. Overimbibers might be put in the stocks, heavily fined, thrown in jail or publicly shamed by having to wear the letter *D* pinned to their clothing (as Robert Coles was forced to do in Massachusetts in 1633). To curb drunkenness, magistrates occasionally forbade the "drinking of habits and healths"—the cyclical toasting to the health of the queen or the governor or whoever else the drinkers could think of, a

practice that forced everyone in the room to raise, empty and refill their glasses constantly, giving rise to corrosive benders.

Colonial-era laws also addressed drinking among "single persons" (aka, young people); drinking on military training fields; the selling of spirits in unlicensed homes; who exactly could use public houses (as of the late 1600s, "Negroes," apprentices and servants were forbidden); how drunks might be shamed (by having their names posted in public); and even the banning of dancing and games. Although backgammon, checkers and cards would eventually become common inside public houses, games (specifically "shovel-board") were banned by the court of the Massachusetts Bay Colony in 1647 ("much precious time is spent unfruitfully & much waste of wine & beare occasioned thereby").

Yet these laws were going largely unenforced by 1720, and courts instead turned their attention to collecting excise fees and duties, as well as regulating prices and keeping supply clean. In 1634, Massachusetts set the price of one quart of ale and beer to "no more than a penny," and each state had its parameters for cost—partly because rum and other spirits were de facto currencies in a region where coins and paper money were scarce. Farmers might pay their hands beer, spirits and cider, as did builders; merchants bartered alcohol for other goods and famously traded rum for humans along the coast of Africa.

During the Revolutionary War, when trade stoppages meant that prices might spiral out of control, courts and legislators passed rules to keep them in check. A 1777 tavern receipt from Andover, New Hampshire, shows that West Indian rum sold for two shillings per quart; a bushel of rye, which could be used to make beer, cost four shillings and a sixpence. Earlier that year, New Hampshire's general assembly had declared, "Whereas the exorbitant prices of the Necessary and Convenient Articles of Life, and also of Labour, within this State at this Time of Distress… will be attended with the most fatal and pernicious consequences."

After the war, the drinking continued unabated among citizens and lawmakers alike. The Vermont General Assembly, for instance, traveled from place to place (and pub to pub) to mete out laws. Members drank at places such as East Poultney's Eagle Tavern, which had a cellar taproom with a huge fireplace, beamed ceilings and a brick floor. In 1787, the gentlemen of the assembly thoughtfully recorded every drink they consumed on the job that year. Judging from the entries, legislating was a saucy affair. Governor Chittenden, Colonel Allen, Major Freeman and

others were particularly fond of drams of bitters (two to three shillings each), bowls of punch (two shillings each), mugs of flip (two shillings each), glasses of brandy (four shillings) and "cyder," whose price varied from place to place.

Drinking at home meant imbibing homemade cider, applejack, beer and brandy or purchasing bottles of spirits at the general store. Timothy Hinman ran a general store in Derby, Vermont, from 1798 to 1850 and counted the famous Indian Joe as one of his customers. Records show that Hinman doled out plenty of half-pints, pints, gallons, quarts and gills of rum among the corn, potatoes, pork, flour, indigo, salt and cloth that he also sold. He sold mugs of sling, too, but not flips, which were a singularly tavern-based drink, perhaps owing to the need for a fire to heat the poker that stirred them.

The pale yellow Buckman Tavern still looms over the Lexington Green, with a phalanx of women in period dress poised to lead visitors across the creaky, wide-plank floors. Behind the bar, flip mugs still sit on the shelf, and you can examine the musket ball dent in the front door. Its taproom is immaculate but musty, dim but intimate and somehow brooding.

Part 3

WHAT THEY DRANK

*T*here are drinks, and there are *drinks*—meaning there are the beers, cider, brandy, wines and spirits that colonists drank straight, but there were also the blends that they came up with to enhance or mask a beverage's harder edges. This section fleshes out the building blocks of colonial drinks—mead, rum, ale, cider, whiskey, brandy and Madeira wine—through their history, flavor and influences in early American culture.

ALE AND BEER

I thought good to advertise you of a few things needful; be careful to have a very good bread-room to put your biscuits in, let your cask for beer and water be iron-bound for the first tier if not more.
—Edward Winslow

It was a crisp November day in 1620 when the weary passengers aboard the *Mayflower* rounded a curve and sailed into a harbor teeming with life. Whales, cod and mussels filled the bay, and dotting the wooded shore were "the greatest store of fowl that we ever saw," as one later wrote. It

was a welcome sight for people who had subsisted on hardtack, dried meat and gruel for three months. Yet despite their giddiness, the Pilgrims and their crew had a pressing situation on their hands: they were running out of beer.

The *Mayflower* had set sail from Plymouth, England, stocked with enough hogsheads of beer to keep the passengers and crew sated. Yet a delayed departure and stormy weather in the Atlantic had pushed the *Mayflower*'s provisions precipitously low. The crew had intended to land in the colony of Virginia, hundreds of miles to the south, but dwindling beer compelled Captain Christopher Jones to drop anchor in what would eventually become the Massachusetts Bay Colony. "After we had called on God for direction, we came to this resolution: to go presently ashore again, and to take a better view of two places, which we thought most fitting for us, for we could not now take time for further search or consideration, our victuals being much spent, especially our beer, and it being now the 19th of December," passenger William Bradford noted grimly as the passengers waited out winter anchored in the bay.

Back in England, ale and beer were daily staples, sipped throughout the day for both fortitude and hydration. Like most Europeans, the

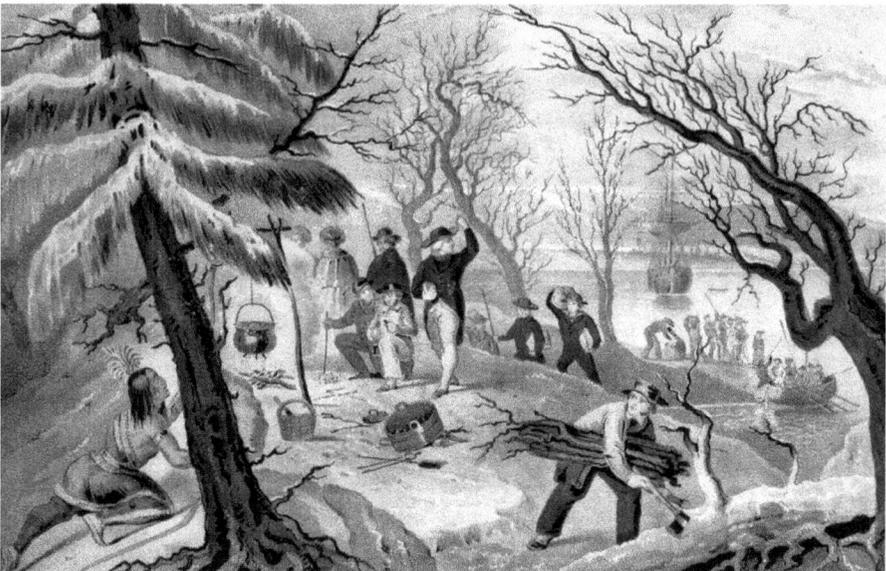

Landing of the Pilgrims at Plymouth, Dec. 11, 1620, by N. Currier. *Library of Congress.*

English avoided drinking water, which could be so filthy in Europe's teeming cities that it often caused sickness. Beer and other fermented beverages were considered safer to drink, full of calories, vitamins and minerals that were vital to the diet—especially for weary travelers crossing an ocean to an unfamiliar new land.

Within a month of setting foot on land, the Pilgrims ran out of beer completely, although the crew did not. As half of the Pilgrims died of hunger and disease throughout the winter and spring, William Bradford complained about Captain Jones's dispassion as he guarded the remaining victuals for himself and his crew, who were promised a ration of a gallon of beer per day. "As this calamity fell among the passengers that were to be left here to plant, and were hasted ashore and made to drink water that the seamen might have the more beer, and one in his sickness desiring but a small can of beer, it was answered that if he were their own father he should have none."

Half of the passengers and crew died during that first brutal winter. In April, the captain and his remaining crew took off back to England, taking the rest of the beer with them. Fortunately, the land where the Pilgrims chose to settle had "many delicate springs of as good water as can be drunk," a luxury and a wonder to those who came from a place where water made you sick. Those who survived and made it through the next harvest were taught by the Wampanoag natives how to ferment alcohol from corn. The Pilgrims imbibed some of this spirit during their first three-day harvest fête, yet beer remained in their mind's eye. They planted barley that first summer, and although malting and brewing were still a ways off, the droves of English settlers who followed in the *Mayflower*'s wake brought with them the knowhow, the grain seeds and sometimes even the malt needed to brew their own beer.

The ale that colonists had swilled back in Europe in the sixteenth century was strong, malty and lacked much in the way of bitterness. English families might spend one-third of their household money on malt, and before hops came along in the 1600s, they used herbs such as coltsfoot, ivy and alehoof to flavor their ales and gruit. When hops made it into the boil in the late 1500s and early 1600s, beer was born, and the sweet, heavy ale that people had sipped for centuries was gradually supplanted by lighter-bodied, sharper beers quaffed inside the nearly sixteen thousand public taverns that peppered England in the late sixteenth century.

English colonists had come from a culture that revolved around taverns and drinking. This image shows a fifteenth-century English public house in Abinger Common, Surrey. *Author photo.*

Despite beer's ubiquity back home, brewing was not as straightforward in the colonies. Although lumber for boiling of wort was plentiful, brewing equipment was scarce, as was skilled labor to brew on a commercial scale. North America had such a roller-coaster climate that barley didn't grow well in the colonies, at least at first, and imported malt could be expensive—especially as colonial courts imposed duties on imported malt in a misguided attempt to jump-start a local grains industry. Even so, Dutch settlers opened the first colonial brewery in New Amsterdam in 1613. In growing colonial cities, heavy demand meant that taverns sold their beer stores quickly, and beer rarely went sour. In rural areas, though, there simply weren't enough bellies for all of the beer a brewery might produce before it spoiled—and beer was too low-alcohol and perishable to be worth transporting very far.

Some hop varieties grew wild in New England, but cultivated hops arrived in Massachusetts in 1628 aboard the Endicott voyage, a mini-flotilla of three ships laden with cows, millstones, grain and the plantable pits of peaches, plums and other fruits, as well as hop roots. By 1629,

the settlers of the Massachusetts Bay Colony were ordering hop seeds from England, and by the middle of that century, hop vines twisted throughout the region. Not only were the plant's sticky, tannic cones used to flavor beer—the oils added pinelike flavors, while the resins acted as a preservative—but they also became a common plant in kitchen gardens, used for fiber, dye and animal food. The youngest spring shoots were even added to salads. Hop cones were sometimes dumped into the beer *after* the boil and before it was left to ferment, a practice that today we call dry-hopping. Since beer casks were often elevated in colonial taprooms, the hops would float on the top of the beer as it was dispensed from below, making for bitter and piney brews.

Beer also requires malt, and early colonists used homegrown barley, wheat and rye for small batches of beer that they brewed at home. By 1635, home breweries were common in the Massachusetts Bay and New Plymouth Colonies. Joseph Adams, the great-grandfather of John Adams, made his living in the 1600s as a maltster, and his malt was widely used by home brewers in neighboring towns. Malting was something of an art rather than an exact science, especially in the age before thermometers. Home malting over a hearth could produce uneven results. Because English grains faltered, too, scrappy colonists often grabbed what they could from the woods, fields and larder to make beer, using molasses, pumpkin and other offbeat flavoring agents to render cloudy, bitter, odd-tasting brews with a spectrum of flavors. Berries, birch bark, spruce tips, pine chips, cornstalks, maple sap—seemingly anything sweet or aromatic was game for beer. Brewing with spruce tips or pine boughs was popular, probably because these plants' resins mimicked the pinelike flavors of hops. Ale composed of wheat and oat malt was called mumm. Bright orange persimmons (which some called "simmons") were native to America, and people undertook a laborious

Early colonial New Englanders sipped beer from breakfast until bedtime—at least when it was available. *Author photo.*

process to turn them into beer. They'd mash the fruit and then blend it with wheat flour, bran or cornmeal; mold this crumble into cakes; bake the cakes in the hearth and then mix them with rainwater; and finally let them ferment. The result was a tart, fruity, funky beer. The stylings of Providence, Rhode Island brewer Major Thomas Fenner offer a glimpse into intrepid colonial brewing methods: Fenner was famous for a beer he brewed with "one ounce of Sentry Suckery or Sulindine one handful Red Sage or Larger ¼ Pound Shells of Iron Brused fine take 10 quarts of Water Steep it away to Seven and a quart of Molasses Wheat Brand Baked Hard. One quart of Malt one handful Sweeat Balm Take it as Soone as it is worked."

As colonists grasped at a mélange of sugars for brewing, an alarmed Massachusetts Bay general court passed a law as early as 1667 to fine those who brewed beer with molasses—perhaps in an attempt to rescue the reputation of colonial beer. Even eighty years later, Swedish minister Israel Acrelius, who traveled the colonies in 1749, called the beers he encountered "brown, thick and unpalatable…drunk by the common people." Yet Hector Crèvecœur, a Frenchman who immigrated to America in the mid-1700s and farmed north of New York City, was charmed by colonial beer's kaleidoscope of flavors: "pine chips, pine buds, hemlock, fir leaves, roasted corn, dried apple-skins, sassafras roots, and bran…With these, to which we add some hops and a little malt, we compose a sort of beverage that's very pleasant." Beer was the drink of choice in early colonial ordinaries, at least until it began to be supplanted by cider and rum in the late 1600s.

Americans labeled the different strengths of beer they produced with X, XX or XXX. Two *X*s on the side of a cask indicated table beer, the style most often served in taverns; one *X* was for small beer, a scant-alcohol drink that was served to servants and children or imbibed by poorer folk who couldn't afford the stronger stuff. Barrels marked with a triple *X* held bracing beers, and these usually made it into the homes and taverns of the colonies' more well-to-do residents.

A fanboy of small beer (and of most things alcoholic) was George Washington. The first president was an enthusiastic swiller of porter, the dark, rich beer that was imported from England from the 1730s up until the Revolutionary War. (Porter had originated as a drink called "three threads," which blended ale, beer and *really* strong beer called twopenny.) Like his contemporaries, Washington had also tried his hand at growing

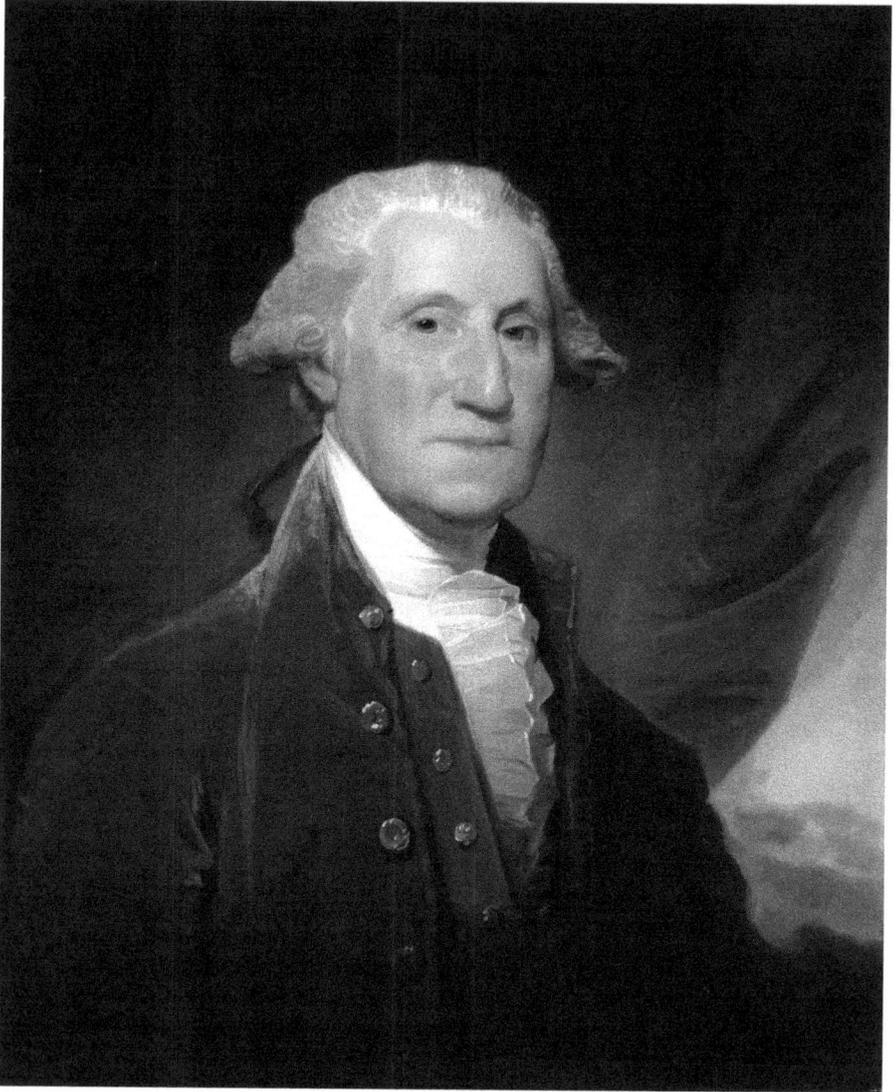

George Washington was an enthusiastic brewer, distiller and imbiber. *Portrait from 1795, Metropolitan Museum of Art, accessed from Wikimedia Commons.*

grapes at Mount Vernon. However Washington seemed especially keen on small beer, which he bottled soon after it was brewed, as it spoiled more quickly than its stronger counterparts. It was also usually consumed quickly and close to home:

To Make Small Beer

Take a large Sifter full of Bran Hops to your Taste.—Boil these 3 hours. Then strain out 30 Gallons into a Cooler, put in 3 Gallons Molasses while the Beer is scalding hot or rather drain the molasses into the Cooler & strain the Beer on it while boiling Hot. Let this stand till it is little more than Blood warm. Then put in a quart of Yeast if the weather is very cold, cover it over with a Blanket & let it work in the Cooler 24 hours. Then put it into the Cask—leave the Bung[hole] open till it is almost done working—Bottle it that day Week it was Brewed.

George Washington's recipe was already becoming a relic, though, by the time he wrote it in the mid-1700s. For decades, rum and cider had been edging out beer as colonists' beverages of choice. Rum was stronger and less perishable, easier to transport around the barely passable roads of rural New England and a commodity that could be used as currency. Even though the molasses used to make rum came from two thousand miles south in the West Indies, rum was still cheaper to produce than beer. So was cider, as apple trees were growing prolifically in the colonies by the late 1600s, and cider making involved none of the lengthy boiling and technical tricks of brewing.

Brewing would remain a quiet part of home and village life, but it wouldn't explode again in America until the mid-1800s, when German immigrants brought along the knowhow (and yeasts) for making crisp lagers. Once lager was introduced, it became America's beer of choice for the next 150 years.

Traditional: Making Beer from the Essence of Spruce

This recipe was written by Founding Father Benjamin Franklin when he was stationed overseas in France. Although I haven't made it and can't speak to its flavors, it's getting easier to find modern iterations of spruce beer from New England breweries that have resurrected the style.

For a Cask containing 80 bottles, take one pot of Essence and 13 Pounds of Molases.—or the same amount of unrefined Loaf Sugar;

mix them well together in 20 pints of hot Water: Stir together until
they make a Foam, then pour it into the Cask you will then fill with
Water: add a Pint of good Yeast, stir it well together and let it stand
2 or 3 Days to ferment, after which close the Cask, and after a few
days it will be ready to be put into Bottles, that must be tightly corked.
Leave them 10 or 12 Days in a cool Cellar, after which the Beer will
be good to drink.

MEAD AND METHEGLIN

No matter where they live in the world, humans generally let no sugar go unfermented, least of all honey. As they learned long ago, blending honey with water will slowly ferment the former into a gold-tinged alcoholic drink—so almost as long as they've held vessels to their lips, they've sipped mead, a cloudy, funky, barely effervescent and mildly alcoholic drink.

The British colonies in America were no exception. Colonists took to fermenting honey with the same verve as they did corn and malted grains. Although honey wine, or hydromel, wasn't as huge a presence in New England as it was farther south, mead got an unexpected mid-1600s boost in New England when the court of the Massachusetts Bay Colony passed laws that were aimed at boosting brewing (by imposing duties on foreign malt) but that had the unintended effect of turning home brewers

Mead and metheglin are fermented from the honey made by bees.

to other sources of sugar, such as molasses and honey. Since spices were part of the colonial larder, metheglin—or mead spiced with nutmeg, mace and other spices—also became a common drink, as did acerglyn, a mead made from maple syrup. (They also occasionally sipped braggot, a drink that fuses mead, beer and spices.)

Mead and metheglin were easier to make than beer. They were produced by boiling large quantities of honey with spring water, occasionally spiking that mixture with ginger, mace and other spices and then leaving the slurry to ferment in a barrel for six months or more. A colonial-era history of the Carolinas, written by historian John Oldmixon, notes that "the bees swarm there six or seven times a year, and the metheglin made there is as good as Malaga sack." Yet American mead wasn't all rosy swill: Swedish minister Israel Acrelius, who lived in Delaware in the mid-1700s, noted in his memoir how American impatience could lead people to bottle metheglin too early. "Drunk in this country too soon, it causes sickness of the stomach and headache," he complained. Another colonial-era traveler wrote that "metheglin does stupefy more than any other liquor if taken immoderately and keeps a humming in the brain which made one say he loved not metheglin because he was wont to speak too much of the house he came from, meaning the hive."

Then as now, honey was an expensive commodity, and metheglin likely never caught fire in taverns because it was far more expensive to drink than beer, cider or rum. In 1729, the court in New Jersey set the price of a quart of metheglin at nine pence, twice as much as cider, one-third more than the cost of a gill of brandy and three times as much as a gill of rum.

From Elizabeth Moxon in 1764 (as documented in *English Housewifry*), here is a recipe for "Strong Mead":

To thirty quarts of water, put ten quarts of honey, let the water be pretty warm, then break the honey, stirring it till it be all dissolv'd, boil it a full half hour, when clean scum'd that no more will rise, put in half an ounce of hops, pick'd clean from the stalks; a quarter of an ounce of ginger sliced (only put in half the ginger) and boil it a quarter of an hour longer; then lade [ladle] it out into the stand thro' a hair-sieve, and put the remainder of the ginger in, when it is cold, tun it into a vessel, which must be full; but not clay'd up till near a month: make it the latter end of September and keep it a year in the vessel after it is clay'd up.

And from Mary Randolph (in *The Virginia Housewife*), here's one for "Hydromel, or Mead":

> *Mix your mead in the proportion of thirty-six ounces of honey to four quarts of warm water; when the honey is completely held in solution, pour it into a cask. When fermented, and become perfectly clear, bottle and cork it well. If properly prepared, it is a pleasant and wholesome drink; and in summer particularly grateful, on account of the large quantity of carbonic acid gas which it contains. Its goodness, however, depends greatly on the time of bottling, and other circumstances, which can only be acquired by practice.*

WINE

Reflect on the position Providence has given the elbow. Man, who was destined to drink wine, has to be able to carry the glass to his mouth. If the elbow had been placed closer to the hand, the forearm would have been too short to bring the glass to the mouth: if closer to the shoulder, the forearm would have been so long that it would have carried the glass beyond the mouth. Let us then adore, glass in hand, the beneficent Wisdom. Let us adore and drink.
—Benjamin Franklin

Long before America became a poster child for independence and swagger, it suffered a failure that England perhaps never really forgave it for: it never became the New World's Bordeaux.

At first, the prospect for American-made wines looked promising. When Norse vikings arrived in Newfoundland in the eleventh century, they immediately noted how dense the place was with vines—so many vines, in fact, that they called the new continent Vinland. A few centuries later, the English colonists who reached the Virginia coast also spied vines curling around tree trunks and creeping along shorelines. A little farther south, along the coast of the Carolinas, Italian explorer Giovanni da Verrazzano noted "many vines growing naturally, which growing up, tooke hold of the trees as they doe in Lombardie, which if by husbandmen they were dressed in good order, without all doubt they

An etching of the muscadine grape. When the first settlers arrived on the East Coast of America, they found prolific wild grapevines.

would yield excellent wines." English explorer Sir Walter Raleigh also waxed poetic after landing in the Carolinas: "We found such plentie, as well there as in places else, both on the sand and on the greene soile on the hils, as in the plaines, as well on every little shrubbe, as also climbing towards the tops of the High Cedars, that I think in all the world the like abundance is not to be found."

There were so many wild grapes in the New World that profit-hungry European rulers and merchants soon gambled on the prospect that America might become a fountain of wine as well as oil and silk. Although more wild grape varieties grow in America than anywhere else in the world, they didn't include grapes such as Cabernet Sauvignon, noble varieties that produced the wines to which European palates were accustomed. The main grapes that grew in

the colonies, *Vitis riparia* and *Vitis labrusca*, were far removed from the *Vinis vinifera* grapes that produced clarets, Burgundies and Rhine reds, and the vines that Nordic explorers first stumbled on in Canada were *Vitis labrusca*, a floppy-leafed plant with either gold or purple grapes and a distinctive musky flavor that was eventually labeled "foxy." The vines' exuberant leaf growth somewhat outpaced the diminutive size of the grapes, too, a potential warning sign that this was not fruit that could easily be made into palatable wine. Instead, American grapes were often small, tart or sour and matured in an extremely variable climate not well suited for ideal *brix*. Blazing summers, such as those in Virginia, could make for overly sweet grapes; New England's more frigid climes meant that grapes there usually yielded sharp juice that was high in acid.

Still, many early emigrants from England had been sent to the colonies by merchant companies, and they persisted in trying to raise grapes—sometimes to the exclusion of growing food. At the mouth of Florida's St. John's River in the mid-1500s, a colony of French Huguenots nearly starved during its first year in America. A passing pirate named John Hawkins left the hungry settlers some provisions, but he later noted (somewhat snarkily) that "in the time the Frenchmen were there, they made 20 hogsheads of wine," without growing anything to feed themselves.

The earliest efforts at growing American wine, centered in Virginia, were an epic failure. *Vinis vinifera* simply would not take on the damp, cool East Coast. Rot, mildew and pests consistently buffeted vineyards. In Jamestown, Virginia, just over one hundred English emigrants arrived in 1607 to produce wine and silk for the Virginia Company; yet even as the company called the Virginia earth "strong and lustie," that same soil produced clunky, ungraceful wines. When Captain John Smith, who sailed with some of the original emigrants of the Virginia Company, wrote in 1612 that "of hedge grapes, we [the Virginians] made neere 20 gallons of wine, which was neare as good as your French British," he was likely stretching the truth.

Still, the chartered companies pushed their agenda. In 1619, the Virginia Company still required every household to "yearly plant and maintain ten vines until they have attained to the art and experience of dressing a vineyard either by their own industry or by the instruction of some vigneron." That same year, eight Languedoc winemakers arrived in

Virginia, but their efforts didn't have lasting import; soon it was tobacco, rather than grapes, that ruled the Virginia fields.

Farther north in New England, stabs at grape growing also faltered. Rhode Island's 1663 charter, written by King Charles II, "gives all fitting encouragement to the planting of vineyards with which the soil and climate seem to concur." People who settled in New England were more inclined to drink rum, beer or Madeira, which were either made at home, distilled nearby or flowed freely into the ports here. Even so, Massachusetts's earliest governor, John Winthrop, planted grapes on Governor's Island in Boston Harbor in 1629; grapes were also planted in profusion at the mouth of Maine's Piscataqua River. Like their compatriots to the south, however, coastal New Englanders keen on making their own wines were destined for failure. It would be more than a century until anything resembling a wine industry gained a foothold in the North, in upstate New York.

In rural New England, though, farmers collected wild "foxy" grapes from the woods to make *truly* native wines. These fruity, funky wines—ranging from honey-sweetened to as dry and rough as sandpaper—weren't meant for export but were instead intended to be drunk at home over dinner. And colonists did not necessarily drink wine straight: Wine could be repurposed into hot mulled wine, a warm drink laced with spices, or into punch. Wine blended with warm milk and sugar rendered a drink called a syllabub, and the traveler Israel Acrelius noticed that Americans were keen to blend wine with "anise-water, cinnamon-water, apples-in-water, and others."

Intrepid New Englanders also made wines from native American plants such as chamomile, rhubarb, plums, nettles, mulberries, gooseberries, dandelions and rosehips. There was virtually no plant that a rural New Englander wouldn't try and subjugate into wine. Even today, dandelion wine persists as a folk mainstay of New England; even though dandelions weren't native to New England, this English import grew readily and widely, as the yeasts on the bright yellow flowers could jump-start fermentation.

Despite colonists' fumblings with native wines, many Founding Fathers were intense in their pursuit of an authentically American wine. With expensive duties imposed on imports from the Continent, French and Canary wines could cost upward of one dollar per a gallon, and so they only made it into the glasses of those who could afford them— much as it had been back in England. In taverns, that imported wine

was sold by the glass, a service called "drawing wine," with claret and Canary wine costing more than other drinks. Yet since wine was one of the favorite drinks of moneyed classes, including the earliest Patriots, the drink enjoyed legislative favors that bolstered its place behind the colonial bar.

Thomas Jefferson was perhaps the most famous colonial oenophile, a passionate wine advocate and connoisseur. He became interested in wines and viticulture during his diplomatic service in France during the 1780s, touring vineyards in Alsace, Burgundy, Bordeaux, Champagne and the Rhone and Rhine Valleys. He collected twenty thousand bottles of European imports as president and advised George Washington, John Adams, James Madison and James Monroe on vintages to grab. He plied his White House guests with both Burgundies and dishes such as coq au vin and crème brûlée that his French-trained black chefs cooked for him. He also maintained a jaw-dropping cellar at Monticello, where he planted vineyards. "We could, in the United States, make as great a variety of wines as are made in Europe, not exactly of the same kinds, but doubtless as good," Jefferson wrote. Yet like many aspiring colonial viticulturalists, Jefferson was bound for disappointment—the wines were never up to the standard that he expected.

George Washington also planted grapes at his home, Mount Vernon, as early as 1768, but he was frustrated by how poorly *Vinis vinifera* performed in American soil. In 1771, before the Revolutionary War began, he also planted vines of a native grape called *Cordifolia*, which takes well to harsh winters. Yet since grapevines take three years to begin bearing fruit, by the time his *Cordifolia* was bursting into fruit, Washington was on to bigger pursuits—namely, leading the Continental army.

Wine swilling was an expensive habit that spread like a virus through the ranks of the Patriots and Founding Fathers. Aaron Burr, the dueler and murderer of Alexander Hamilton, was also an enthusiastic swiller of wine and, in turn, introduced Andrew Jackson to the *vino*. Ben Franklin was also a sot, marinating in porter, Champagne, brandy, Madeira and the fine wines of France, a country he traveled to often. "He was particularly partial to the wines of Burgundy," wrote Albert Henry Smyth, who edited his papers, "and brought on access of gout with the copious draughts of Nuits with which Cabanis plied him at Auteuil."

Yet the Revolution put a serious dent into the perception of wine from which it would take a long time to recover. With its higher duties

Left: After the Revolutionary War, wine was seen as a slightly undemocratic drink. *Author photo.*

Right: A handful of grapes. *Author photo.*

and European origins, wine was considered "elitist and undemocratic," as drinks historian W.J. Rorabaugh noted. After the Revolution, those who wished to drink it redoubled their efforts to plant American vineyards—Thomas Jefferson led the charge—but it would be decades before anything resembling an industry would gain a foothold in the United States.

Traditional: Hot Mulled Wine

This is adapted from a recipe developed by Old Sturbridge Village, which itself created it based on an 1851 recipe. Mulled wines were more commonly sipped during the Victorian era than the colonial era, but mulled wine also weaves together many of the flavors used in early American drinks. Be careful not to let the wine boil, as the spices can turn bitter.

2 cups water
dash of nutmeg
2 sticks cinnamon
I tablespoon cloves
I bottle medium-bodied red wine, such as Shiraz

Boil together water with nutmeg, two broken-up cinnamon sticks and a tablespoon of cloves that have been slightly pounded. When reduced by one-half, strain the liquid into a quart of wine, set it on hot coals (aka your burner), take it off as soon as it comes to a boil and sweeten it. Serve it up hot in a pitcher, surrounded by glass cups and with a plate of rusks (aka Melba toast).

Modern: Mulled White Wine

For those who find red mulled wine too weighty, this version is lighter and brighter but still might lull you to sleep after one mug. It also avoids allspice.

1 bottle white wine, such as Riesling
¾ cup water
2 tablespoons superfine sugar (or to taste)
2 star anise
1 bay leaf
1 vanilla pod
1 cinnamon stick
4–5 cardamom pods, cracked
2 slices of ginger
dash of orange zest
orange wedge
scrape of fresh nutmeg

In a saucepan, combine wine, water and sugar and set over low heat. Add star anise, bay leaf, vanilla pod, cinnamon stick, cardamom pods, ginger and orange zest. Stir while heating to a simmer, then simmer for 10 minutes, carefully avoiding a boil. Add orange wedge to a mug and strain wine into the mug. Grate some fresh nutmeg on top and serve hot. (Note: A shot of ginger liqueur, such as Domaine de Canton, will give this extra zotz. If you use it, reduce sugar slightly.)

BRANDY

Before there was gin, before there was rum or whiskey or vodka, there was *eau de vie*, the distilled essence of grapes, apples or other fruit. Brandy was among the first distilled drinks, one that would become so integral to the colonial-era French empire that its lawmakers would perform legislative somersaults to protect it. It was also plentiful behind colonial-era bars—at least in cities.

Essentially the distillate from grapes, brandy was born in the twelfth century on the alembic still. By the Middle Ages, wine merchants were distilling their grape wines in order to concentrate them for cheaper transport. Their plans included reconstituting the distillate with water once it reached its destination. Once drinkers discovered that brandy tasted better after some time spent in casks, the drink found its way into many medieval cups and created a sort of brandy diaspora as France and Spain conquered and colonized various far-flung regions and islands.

In the early 1600s, before rum became a tool for trade, French and English ships would park in the waters off the Senegalese coast, and men in canoes would ferry boats full of booty to the shore, then load newly purchased slaves back on to return to the ships. These "ferrymen" were often paid with bottles of brandy, making it one of the earliest spiritous currencies.

Brandy was also imported into the colonies, and barrels of it were almost always on hand in tavern stores. At the Sign of the Sun, a Boston tavern of the 1720s, licensed keeper Samuel Mears kept more brandy (197 gallons) on hand than rum (123 gallons). Brandy would be sipped straight after dinner or combined with lemon juice, sugar and water to make brandy punch, a slightly more floral punch than versions made with rum. Brandy blended with tea was called a meridian, and certainly barkeeps had innumerable other ways to dress up their brandy.

Brandy also played a role in the rise of the New England rum industry. Because French brandy producers didn't want rum imported into their country from the French West Indies, most of the molasses produced on islands such as Martinique was buried or thrown into the sea—until colonial ships began snapping it up for their own burgeoning rum industry.

Out in the sticks, rural New Englanders didn't have much in the way of grapes—or even stills—but apples, gooseberries, cherries, plums and raspberries grew in abundance, and they would add their juices to bottles of brandy, creating juicy libations such as cherry bounce.

Modern: Slippery Lemon

Perhaps in some fire-lit New England tavern of yore, a creative barkeep decided to blend an odd bottle of imported gin with some apple brandy, maple syrup and fresh lemon juice. Probably not. Yet brandy's oaky notes ground sharp, aromatic gin, and a drip of maple syrup adds roundness.

ice
2 ounces apple brandy
1 ounce dry gin
½ ounce dry vermouth
½ ounce fresh lemon juice
dash lavender or other floral bitters
1 teaspoon maple syrup
lemon twist (or slice of lemon)

Fill a shaker with ice and then add all ingredients except for the twist. Shake hard to combine and then pour the entire blend, ice and all, into a tumbler or rocks glass. Garnish with lemon twist and serve.

MADEIRA AND SACK

These noble old wines have a variety of dominant flavors, with what I might call a changeful halo of less decisive qualities. We call the more or less positive tastes apple, peach, prune quince; but in fact these are mere names. The characterizing taste is too delicate for competent nomenclature. It is a thing transitory, evanescent, indefinable, like the quality of the best manners. No two are alike.
—*Mr. Wilmington in* A Madeira Party *by Silas Weir, 1895*

In 1768, John Hancock was barely thirty, but he was already pretty adept at making money. He had inherited an importing business from his uncle, Thomas Hancock, and was skilled at bringing (as well as smuggling) molasses, paper, Dutch tea, rum and other choice sundries into Boston, a busy colonial port. He was also crafty at eluding British-imposed customs and duties. In the spring of that year, he barred British officials from inspecting the hold of one of his ships, the *Lydia*, as it arrived in Boston Harbor. A month later, he tangled with the same authorities again as they boarded another of his ships, the *Liberty*. In the *Liberty*'s hold, they found twenty-five pipes of Madeira wine—about one-fourth of that ship's capacity. Suspicious that Hancock had unloaded most of the cargo before inspection, they charged the merchant with four times the duty on what they found. The subsequent seizure of the *Liberty* caused violent riots in Boston, and although Hancock was charged with smuggling, he was acquitted due to lack of evidence. His lawyer during the confrontation was John Adams.

Missing pipes of Madeira were the smoking gun during the *Liberty* affair possibly because full pipes of Madeira were in such heavy demand in 1700s New England. The fortified wine had been ever-present in colonists' lives since they had learned the hard truth that fine wines came dearly across the pond. Although wild grapevines carpeted the New World, those native grapes yielded barely drinkable plonk, and French claret could suffer and spoil during its steamy, roiling trip across the Atlantic. Those that did survive often landed instead in the cellars and glasses of wealthier folk, but only after incurring expensive duties from the British, who taxed almost anything that the colonies imported from Europe.

Whereas French and Spanish Cabernet and Riojas wilted during their transatlantic journeys, there was one wine that didn't suffer from its hot Atlantic journey—instead, the rich fortified wines produced on the island of Madeira gained complex layers of flavor from the same sticky, steamy passage.

Madeira was (and is) a wine made in the place of the same name, a north Atlantic archipelago a few hundred miles off the coast of Morocco. In 1419, when Portuguese explorer Captain João Goncalves "discovered" Madeira, its mountainous interior was blanketed in laurel forests so thick that he couldn't wander far from the shore. After Zarco (as the captain was called) claimed the island for Portugal, he resolved to rid it of its

impenetrable forests so that it might be cultivated—to wit, he set fire to the island and let it burn. And burn. And burn some more. Zarco and his Portuguese backers waited seven years for the flames to fully burn themselves out. Once they did, Madeira's volcanic soils were laced with nutrients from the ash and ready for the planting of sugar, grapes and other crops.

Zarco's countrymen soon flowed onto the island from Portugal, joined by emigrants from Italy, Spain and across Europe. They planted vines on the island's steep slopes—mostly a white grape called Malvasia, or what the British called Malmsey, but also Boal, Sercial and Verdelho. Once the grapes were plucked in the fall, the Madeirans would crush them with their bare feet in long wooden vats called *lagares* and then transfer them into wooden casks for aging.

At first, these wines were drunk locally or shipped out as-is to England and points north and west. Early in its life, though, Madeira wine was the victim of a happy accident. The myth of Madeira dictates that a forgotten barrel of the stuff destined for the British colonies in India came back, undiscovered and undelivered, in the bottom of a ship's hold. Whoever tasted that wine met with liquid pleasure: the heat and the roiling motion of the passage had imbued the wine with a spectrum of complex caramel and nut flavors. Once winemakers (and consumers) realized that steamy ocean trips catalyzed Madeira's aging process, pipes of Madeira—or casks of 126 gallons each—were intentionally shipped around the world to gain their unique host of flavors. They were labeled *vinho de roda*, or "wines of the round routes."

Madeira's ensuing popularity wasn't solely due to its flavors, though; shifting politics and alliances helped boost its cred in the American colonies. Since Britain had an exclusive trading agreement with Madeira after King Charles II married Portuguese princess Catherine of Braganza in 1662, an easy, unimpeded flow of Madeira wine made it into Britain, and it was a taste that some emigrants took with them when they moved to the colonies. It was a thirst that global trade was able to easily fulfill: the island of Madeira fell in the midst of several trade routes, and the sloops that stopped off in Madeira's port city, Funchal, to reboot supplies also picked up wines that they transported to the British colonies in America.

Due to the maze of duties and fees that Britain imposed on the colonies, European imports were expensive by the time they arrived stateside. Wines from Madeira, though, were exempt from this rule

and could arrive unmolested and untaxed into colonial ports onboard Dutch, Spanish or Portuguese ships. Since Madeira escaped the corrosive touch of British hands, it became a popular drink among Patriots who were driven batty by English taxation. By 1740, Madeira was a wildly popular libation in Boston and New York, but its epicenter was Philadelphia, where festive Madeira drinking parties and clubs flourished.

Even in their infant state, the colonies began to show regional divisions in food and drink customs, and this was evident with Madeira. Southerners tended to gravitate to the richer Madeiras made from the Sencial grape, while New Englanders swilled sweeter Madeira made from Malmsey. By the mid-1700s, the Madeirans had begun adding a small dose of brandy before fermentation was complete to fortify the wine against spoilage. Madeira became the stronger for it—usually 20 percent alcohol—and its strength further endeared it to a colonial populace that preferred to waste no shillings getting saucy.

As tensions rose between the colonies and England, Madeira also became the unwitting, inanimate patriot of the American Revolution—not only during the *Liberty* affair but also in unfolding events before the Revolutionary War. Just before it began, Benjamin Franklin met with Governor George Clinton of New York to ask him for more firepower to defend Boston. At first, the governor wavered, but after a few "bumpers" of Madeira, the night improved. "He at first refus'd us peremptorily; but at dinner with his council, where there was great drinking of Madeira wine, as the custom of that place then was, he softened by degrees, and said he would lend us six. After a few more bumpers he advanc'd to ten; and at length he very good-naturedly conceded eighteen," Franklin wrote in his autobiography.

Franklin was a great lover of wine, yet he also thought that Madeira possessed almost magical powers of preservation. In 1773, the inventor claimed to have revived three flies that had drowned in a bottle of Madeira by scooping them out and placing them in the sun: "They commenced by some convulsive motions of their thighs, and at length raised themselves upon their legs, wiped their eyes with their fore feet, beat and brushed their wings with their hind feet and soon after began to fly."

As he corresponded with a French scientist later that year, Franklin wrote, "I should prefer to an ordinary death, being immersed with a

few friends in a cask of Madeira, until that time, then to be recalled to life by the solar warmth of my dear country!"

Madeira consumption also raged *during* the war for independence, when troops of the Continental army swilled liquor, beer and wine before battle (that is, if it was available). Before Pennsylvania general John Cadwalader led his troops into combat, he (and they) sipped Madeira. Before George Washington put on his boots to head out to battle, he sipped Madeira. By many accounts, the future president also sipped a pint of Madeira every night with dinner. Ben Franklin had Madeira at his elbow as he helped write the Declaration of Independence. After the war, the first Supreme Court justice, John Marshall, was a fervent Madeira enthusiast, as were a few of his fellow justices.

The Madeira wines of today are not dissimilar from what enraptured our forefathers three hundred years ago, although they're now aged in hothouses instead of in the holds of ships. A pour of slightly aged Madeira might reveal a cola-colored, slightly cloudy drink with swirling aromas of figs, caramel, spices and sometimes leather, almost like a wine that's been left out in the sun. A Madeira that's been aged for ten years or more will yield even more complex flavors that can range from grapefruit peel to caramelized sugar.

Like Madeira, sack (the colonial word for sherry) was also tossed back in copious amounts, another benefit of international trade. The word comes from the Spanish word for extraction, or *saca*, to describe how this wine's flavors emerge in a solera system in southern Spain's Jerez region. Although sack is made solely from the Palomino grape, its flavors could be all over the map: Fino sherry is golden-hued with nutty notes, while Oloroso sherry is deeper, darker and more oxidized, and Amontillado sherry falls somewhere between the two.

Madeiras and fine sherries are best sipped straight, but both can work as earthy, grounding flavors in mixed drinks. Sack posset, or sack blended with egg whites and beer, was a popular colonial drink during weddings (see the recipe under "Posset" on page 87), while colonists often spiked their beloved punches with Madeira, which added both strength and spice.

Modern: Ginger Fizz

Madeira was once seen as a squirt in the eye to Britain; marrying the wine with a dram of the quintessentially English spirit Pimm's buries that hatchet once and for all.

ice
1 ounce Madeira wine
1 ounce Pimm's
sprig of mint
2 ounces ginger beer

In a tall Collins glass filled with ice, combine Madeira, Pimm's and mint. Swirl to combine. Top with ginger beer, stir again and serve.

Modern: Sack Blossom

Sherry (aka sack) plays nice with tequila. The smoky elements of the latter offer a moody counterpoint to sack's almondy notes. This drink also weaves together elderflower, bitters and fresh orange juice for a floral, complex drink.

ice
1½ ounces Blanco tequila
½ ounce dry sack
½ ounce St. Germain Elderflower liquor
dash of orange bitters
1 teaspoon fresh-squeezed orange juice
orange twist

Fill a cocktail shaker with ice. Add tequila, sack, St. Germain, bitters and orange juice and shake until the shaker gets frosty. Strain the drink into a coupe glass and garnish with orange peel—flame it for an extra layer of flavor.

CIDER

Planting, hoeing and haying—farming in New England's rocky soils could be backbreaking, dawn-to-dusk work, its edges softened only by a nap or something spiritous. Often, that little *something-something* was hard cider, pressed and swilled by the farmer himself.

"The confirmed cider drinker would sometimes drink enough to intoxicate three ordinary men, at least," wrote Andover historian John Eastman. "A Small farmer on Beech Hill would drink a quart of cider without moving the pitcher from his lips, and with no outward sign of swallowing; the cider ran down his throat continuously as if it had been a large rubber tube."

Early Americans imbibed hard cider with gusto, and cider took its place in the colonial larder quickly. When the earliest English settlers arrived in the early 1600s, the only apples they encountered, if any, were

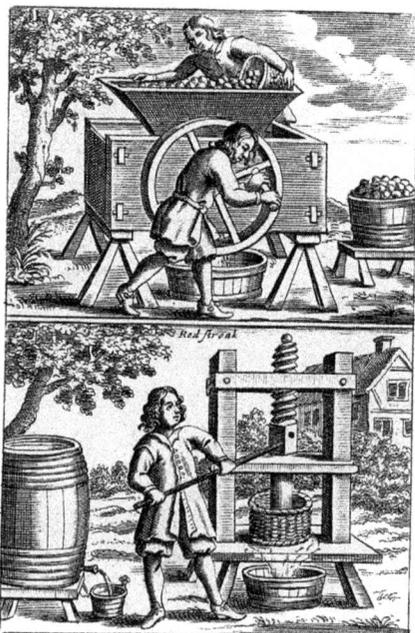

Hard cider was a staple in rural England. Once apple trees matured in the New World, colonists drank it there as well. *Print from* John Worlidge's Vinetum Brittanicum, or A Treatise on Cider, *1689.*

tiny, tart crabapples—veritable midgets compared to the apples that grew back home. Although the hills, lakes and coasts of New England brimmed with fish, oysters, corn, pumpkins, deer, turkey and herbs, apples were just a glimmer in someone's eye, at least until settlers pulled cuttings and seeds from their bags and planted them throughout their appleless New World.

Most apple trees bear fruit by the time they're ten years old, and often sooner. Since apples grow best in colder climes, it was primarily New England—rather than Virginia and points south—where orchards became an integral part of farms by the mid-1600s. And because most of New England's settlers were English, English cider making traditions took firm hold here. There, hard cider had been a cornerstone of life for centuries, especially the dry ciders of Herefordshire, where the apple orchards were legendary. It was in England where cider first migrated from tapped barrels to bottles, which sometimes produced effervescence that preserved the drink; it was also in England where producers began taking notes on how various types of apples tasted once they were pressed, fermented and bottled.

Across the pond, scrappy Pilgrims didn't have the time or the inclination for such connoisseurship, but they still blanketed the landscape with apple trees. The early propagation of apples had a few intrepid souls to thank, especially William Blackstone, an iconoclastic ex-minister who was one of the only men to stay behind in Massachusetts after his expedition returned to England in 1625. Blackstone settled onto a farm on Boston Common, the only European soul in what would eventually become a city of thousands and then millions. When more of his countrymen inevitably began arriving, Blackstone was needled enough by the Puritans (he was an ordained Anglican minister) that he picked up and moved to a secluded hillside in Rhode Island, where he began another farm and planted an orchard. That orchard bore what is often considered the first truly American apple, the Yellow Sweeting—a variety oft recultivated by "orchardists" throughout the colony. (To add to William Blackstone's general fabulousness, he briefly returned to Boston in 1659 riding a domesticated bull, but his home, and impressive library, were destroyed by fire in 1675, a year after his death.)

As William Blackstone and other orchardists knew, apples are similar to grapes in that the plant that eventually emerges from an apple seed

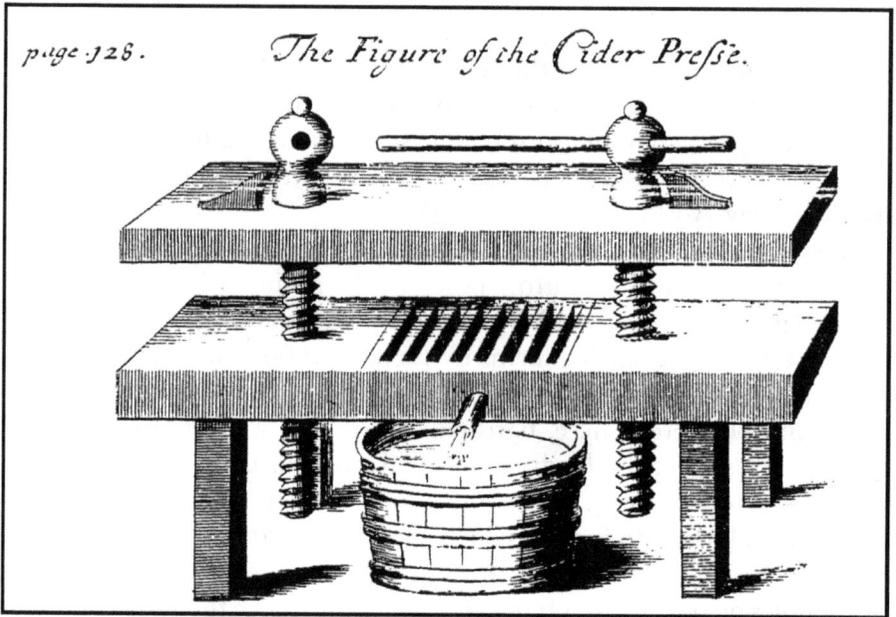

A cider press from John Worlidge's *Vinetum Brittanicum*.

is unpredictable and unique; what comes from a grafted vine, however, reflects the genetics of the parent plant. Since most colonists were relatively poor, grafting wasn't common, especially in interior New England—what sprouted there was a kaleidoscope of apples of every hue, size, shape and tartness. Often, they were sharp, tannic and bitter— ideal for making cider. Pressing and fermenting their juices both created a swillable alternative to water, which was still widely mistrusted, and preserved apples (at least in liquid form) through the seemingly endless winters, especially if fortified with brandy.

Cider was an almost uniquely New England drink, and it began bumping beer down a notch on the tavern totem pole since it was easier and cheaper to produce—no tanks, heat, grain or skilled labor necessary. Farmers simply needed to mill and press their apples with either a pressing stone, a wooden screen or a cider mill to release the juices and let these ferment in casks using natural yeasts. Cider would turn "hard" within two or three weeks after pressing, and this cider could be sipped at home or in the fields or sold to the local licensed public house. By the

1660s, the first colonial laws had appeared that required a license to sell cider, suggesting that it had become a common colonial drink.

The man of the house drank cider with his breakfast, ladies sipped it at teatime and children drank a low-alcohol version made from the fermented second pressing of the pomace. The cantankerous future president John Adams may have been even moodier without his a.m. tipple, a tankard (about two pints) of hard cider every morning before breakfast. As he wrote in his diary in 1796, "In conformity to the fashion I drank this Morning and Yesterday Morning, about a Jill of Cyder. It seems to do me good, by diluting and dissolving the Phlegm or the Bile in the Stomach."

There was plenty of cider around to satisfy him. By the mid-1700s, the average New England family might consume a barrel of cider a week, putting up dozens of barrels for the winter. In Middlesex County, Massachusetts, in 1771, a population of 14,028 produced 22,780 barrels of cider in one year—a barrel and a half for every man, woman and child. By 1775, one out of every ten New England farms had its own cider mill. In 1776, the State of Vermont recorded 173,285 gallons of hard cider produced within its borders. Some rural taverns made their own cider from their own orchards, such as the early 1800s Charlestown, New Hampshire tavern owned by Stephen Hassam, who maintained a five-acre lot to make modest amounts of cider—fifteen to twenty barrels per year.

Visitors to the colonies found that cider could be quite refined as well as copious. John Josselyn, a 1600s writer and traveler, wrote, "Syder is very plentiful in the Countrey, ordinarily sold for Ten shillings a Hogshead." In the "Tap-houses" of Boston, Josselyn encountered "[a]le-quart spic'd and sweetened with Sugar for a groat." Over dinner at a Connecticut farmhouse in 1790, the French writer and gastronome Jean Anthelme Brillat-Savarin sampled "huge jugs of cider so excellent that I could have gone on drinking it for ever." No small words from a Frenchman.

As with rum and beer, colonists blended cider into a mélange of mixed drinks, such as Stone-Fences (a blend of cider and rum) and syllabub (cider blended with cream, rum and sugar, although wine could be used in place of cider). They would mull cider with egg yolks, sugar, rum and spices; they would also make a drink called egg cider by cracking a few eggs into heated cider and sweetening it with molasses or sugar.

Swigging cider wasn't confined to the country. The selling of spirits was banned in Boston taverns in 1712, and tavern inventories show that licensed houses tended to keep hundreds of gallons of cider on hand, almost to the exclusion of beer (but certainly not to the exclusion of rum). The King's Head Tavern, owned by James Pitson from 1714 to 1737, generally had hundreds of gallons of cider on hand compared to a relatively paltry few dozen bottles of beer. Granted, Pitson was a trained English cider maker, but even the nearby Marlborough Head Tavern, run by a widow named Sarah Wormall, had between 130 and 150 gallons of cider on hand when she died in 1721.

Such robust cider drinking would eventually pave the way for the temperance movement. Even though it was the liberal swilling of rum and whiskey that would whip temperance advocates into a frenzy, comparatively mild hard cider would suffer as a result. In the mid-1800s, some New England farmers would chop down their orchards to comply with temperance crusaders.

RUM

It is an unhappy thing that in later years a Kind of Drink called Rum has been common among us. They that are poor, and wicked too, can for a penny or two-pence make themselves drunk.
—Increase Mather, 1686

The bewigged, mournful Increase Mather had a heavy weight to bear: he was charged with upholding the faith's mores against sex, sorcery and especially drunkenness. Although the Puritan parson himself wasn't above the occasional tipple—the minister of Boston's Old North Church and president of Harvard University wouldn't refuse a pint of ale, some Madeira, glasses of wine or even the occasional dram—he detested drunkenness. As Mather wrote in 1673, "Drink is in itself a good creature of God, and to be received with thankfulness, but the abuse of drink is from Satan; the wine is from God, but the Drunkard is from the Devil."

It was another libation that would come to preoccupy Increase Mather, son Cotton and countless parsons, judges and lawmakers for much of the

next century—a fiery, bracing spirit that would eventually bring both enormous wealth and despair to Massachusetts: rum.

Increase Mather was middle-aged by the time rum began trickling into New England from the West Indies in the 1650s. By the time he was graying under his wig, the minister's home turf of Boston and Cambridge was awash in a tide of rum drinking. The first tavern opened in Boston in 1633, and just over one hundred years later, there were 156 legal places to drink and probably many more unlicensed spots. Rum fueled much of that growth.

The spirit was the byproduct of West Indian sugarmaking. Alcohol distilled from sugar cane wasn't an alien concept, even in 1650. In Brazil, sugar-derived spirit was (and is) called *cachaça*. In West Africa, the intense, colorless spirit made from sugar cane juice is *akpeteshie*. In India and other parts of Asia, it's *arrack*, a spirit derived from coconut sugars. (Rum was sometimes called "arrach" in colonial records.) In the West Indies, the powerful spirit that first dripped from a still in the 1630s was called rum (sometimes rumbullion). Long before it gained a foothold in coastal New England, it was making and swallowing livelihoods two thousand miles south, especially on the island of Barbados.

When Portuguese explorer Pedro a Campos spied Barbados in 1536, he breezily named it "Los Barbados," or "the Bearded Ones," for the bearded fig trees growing there. Nearly a century would pass before another restless European would alight on its shore: English sailor John Powell, who in 1625 stepped onto an empty island whose natives seemed to have vanished. Once John Powell staked it for his Crown, English

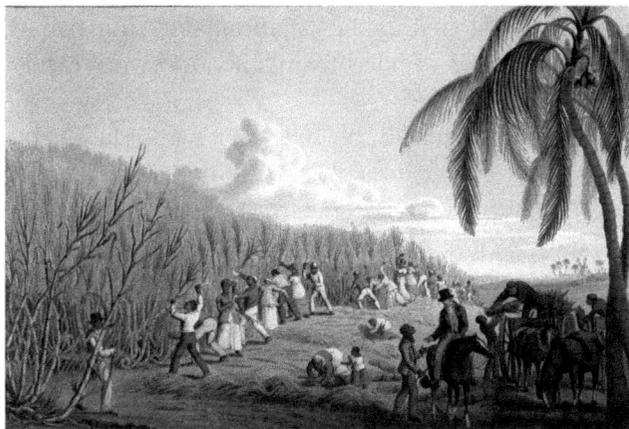

Cutting sugar cane in the West Indies.

residents began arriving two years later, just a few of the thousands of English, Dutch, Spanish and French emigrants seeking their fortunes in the steamy Caribbean.

Barbados's new residents tried cultivating tobacco as well as grapes, yet both crops languished in the sticky climate. What stuck was feathery, fast-growing sugar cane, a plant that flourished in the island's poor soils. In a historical blink, fields of sugar cane blanketed Barbados and nearby islands such as Guadalupe and Jamaica.

Making crystallized sugar from cane was an intensely labor-intensive process, one that called for cheap workers. Within a decade, English sloops delivered people who had been enslaved on the west coast of Africa, swarms of men and women who—if they survived the blazing, cramped, month-long journey—had backbreaking labor in the sugar fields awaiting them on the other end.

Sugar cane grew for up to eighteen months before it was cut, bundled and carted into sugar-making houses, where the stalks were boiled down in huge cauldrons. As scum rose to the top, it was skimmed off; the remaining slurry was then reduced and reduced some more until sugar would form and be set aside to turn into grains. The sticky, viscous brown liquid that dripped from sugar during crystallization was molasses.

For the first few decades of West Indian sugar making, molasses was considered waste, and planters dumped it into the ocean or buried it in the ground, sometimes keeping tiny amounts to sweeten their tea and dishes. By the mid-1600s, though, they had learned that combining molasses with the fermented wash from sugar vats, heating it until it gave off vapors and then condensing those vapors yielded a clear, sweet, powerful liquor. Production was a steamy, nasty affair, one that began with the oozing wastes of sugar and trickled from stills that were rarely if ever cleaned.

Slaves made up slightly more than half of Barbados's population by 1660, and their sweat produced stratospheric profits for the island's sugar barons—both in sugar and rum. The island's rum quickly gained a reputation. It was distilled only once (as opposed to twice or more on islands like Jamaica), so it retained some of its sweetish character. Also, Barbados was blessed with delicious water naturally filtered by limestone bedrock. By the 1650s, Barbados's towns were awash with "tippling houses," and the island had gained a reputation far beyond its shores as a wild, lawless place. Although the sugar barons became filthy rich, most of those who ended up

Cider Slammer

Every fall, this drink comes out of its summer hibernation at the Inn at Weathersfield in Weathersfield, Vermont. Co-owner Spanjian isn't sure who originally dreamed it up, but it's a perennial cold-weather signature.

To Make "Slammer Juice":
1 cup boiled cider*
1 cinnamon stick
1 vanilla bean
a slice of fresh ginger
fresh thyme

Simmer ingredients together for about 20 minutes and then strain and let cool.

For the Drink:
1 orange wedge
1 thyme sprig
ice
1½ ounces (or one shot) bourbon
prepared slammer juice
fresh apple cider

Muddle orange slice and thyme in a glass and then add ice. Add a shot of bourbon and a shot of slammer juice and then top off with fresh apple cider.

**A note on boiled cider: Wood's Cider Mill in Springfield, Vermont, makes a version, but you can make your own by boiling down fresh apple cider until it becomes syrupy.*

Modern: Josiah Bartlett's Hot Toddy

Josiah Bartlett is a New Hampshire—made apply brandy that ages for four years in oak barrels. Like the colonial-era statesman and physician for whom it's named, it's elegant and restrained, with layers of apple, pear, vanilla, toasted caramel and hints of cardamom. It's also smooth as silk in a hot toddy with an orange slice (instead of the traditional lemon) and the slightest drip of honey.

3 ounces hot water
½ teaspoon honey
2 ounces apple brandy
orange wedge, and slice for garnish
cloves (optional)

In a glass mug, pour water over a spoonful of honey and stir to dissolve. Add brandy, squeeze in the juices from the orange wedge and then garnish with orange slice. Add cloves if desired. Sip slowly, savoring the flavors.

Modern: Rye Sling

This tart-sweet drink should be served ice cold and looks elegant served up in a coupe glass or small martini glass.

ice

2 ounces rye whiskey

½ ounce cherry liqueur (such as Luxardo Maraschino)

½ tablespoon simple syrup

2 teaspoons water

1 ounce fresh-squeezed lemon juice

dash of cherry bitters

lemon twist

Fill a shaker with ice and then add rye whiskey, cherry liqueur, syrup, water, fresh-squeezed lemon juice and bitters. Shake for 10 seconds until the shaker is frosty on the outside and the liquids are well blended. Strain into a coupe glass and serve garnished with a lemon twist.

Modern: Brandy Milk Punch

In the South, milk punches are seen as restoratives, balms for an upset stomach—or a hangover. This blend of brandy and milk gets gloriously frothy as you shake it.

ice
1 teaspoon superfine sugar
2 ounces brandy
¾ cup milk
dash of vanilla extract
scrape of nutmeg

Fill a shaker with ice and then add sugar, brandy, milk and vanilla. Shake hard for 10 seconds to combine; lift the top off the shaker gently, as the foam may try to spill over. Strain into a Collins glass filled with ice, sprinkle with a dash of nutmeg and serve.

Traditional/Modern: Basic Ale Flip

Although flips were traditionally made by using a red-hot fire poker, it's eminently more practical (in a modern kitchen, at least) to heat the beer ahead of time. You can still hew to tradition, though, by using two separate pitchers (or mugs) to blend the drink. It really does yield a silky-smooth blend.

8 ounces beer, preferably brown
ale or stout
2 pint glasses
2 teaspoons sugar or 1 teaspoon
molasses
1½ ounces rum
1 egg, beaten
scrape of nutmeg

Warm the beer in a saucepan over low heat until it just begins to froth and then add to a pint glass with sugar and rum. In the other pint glass, add the beaten egg. Pour the egg into the beer, then pour the entire thing back into the first pint glass and continue to combine until smooth. Top with grated nutmeg.

Modern: Hot-Maple Rattle-Skull

This boozy update eschews brandy and sherry for maple liqueur and maple rum, and instead of nutmeg, it uses a sprinkle of chipotle pepper for kick. It also reduces the liquor content slightly, but even though this smooth, silky drink tastes just like little more than tarted-up beer, it still harbors flooring power.

1½ ounces maple rum, such as Dunc's Mill (alternatively, use rum and add a tablespoon of maple syrup)
1½ ounces maple liqueur, such as Sapling
juice from ½ a lime
cola bitters (or any bitters)
bottle of dark beer, such as Berkshire Brewing Co. Drayman's Porter
dash of chipotle powder

In a snifter or half-pint glass, add rum, liqueur, juice from half a lime and bitters. Swirl to combine. Fill the glass with beer and then add a sprinkle of chili powder on top. Serve.

Modern: Dark and Shrubby

This is a twist on the Dark and Stormy, a modern blend of rum and ginger beer. Its ingredients echo colonial drinks, but the zesty shrub bristles well with the ginger beer. The bitters add a layer of spicy flavor. Be careful: You'll probably want a second one.

ice
1 tablespoon blackberry shrub
2 ounces dark rum
dash of Angostura bitters
ginger beer
mint sprig

Add ice to a rocks glass. Dribble in shrub and then add rum and bitters; top with ginger beer. Stir to combine, garnish with mint and serve.

Modern: Sack Spritzer

This rust-hued drink is an earthier version of your run-of-the-mill wine spritzer.

ice
2 ounces dry sack
½ ounce Campari
½ teaspoon ginger syrup (optional)
soda water or seltzer
orange wedge
mint sprig

Fill a wine glass or Collins glass with ice and then measure in sack and Campari. Dribble in some ginger syrup if you have a sweeter cocktail tooth and then fill glass with soda water to desired strength. Garnish with orange wedge (I like to drop it in the glass) and mint and then serve.

Traditional: Stone-Fence

ice
1½ ounces rum
hard cider

Fill a Collins glass with ice, pour in the rum and then top with cider. Stir to combine and serve.

Modern: The Alderman

This drink pairs Madeira with brandy and grapefruit juice for a bracing and citrusy but murky late summer cocktail.

ice
1½ ounces Madeira wine
1½ ounces brandy
½ ounce fresh-squeezed
 grapefruit juice
grapefruit twist

In a cocktail shaker filled with ice, combine Madeira, brandy and grapefruit juice. Shake vigorously until sides of shaker are frosty and then strain over an ice-filled Collins glass. Garnish with grapefruit twist and serve.

Modern: Sack Flip

ice
3 ounces sack (or sherry)
½ ounce bourbon
I teaspoon superfine sugar
I ounce almond milk
I egg
scrape of nutmeg

In a shaker, add ice, sack, bourbon, sugar and almond milk and then carefully break in the egg. Shake vigorously until blended and then strain into a coupe glass and top with grated nutmeg.

Modern: Apply Brandy Sangaree

This drink is a beautiful jewel-like ruby color. It draws on ingredients common to the day.

½ teaspoon superfine sugar
2 ounces apple brandy
1½ ounces rum (I used Dunc's Mill Maple Rum from Vermont)
ice
splash of light red wine, such as Pinot Noir or Beaujolais

In a shaker or pint glass, combine sugar and brandy and stir to combine. Add rum and ice and stir again. Strain into a coupe glass and gently pour a splash of red wine on top. Serve.

Ice-Out

ice
2 ounces applejack
½ ounce good-quality dry
 vermouth
I ounce fresh-squeezed orange
 juice
I teaspoon maple simple syrup
dash of old-fashioned bitters
splash of club soda
orange twist for garnish

In an ice-filled shaker, add applejack, vermouth, orange juice, simple syrup and bitters. Shake to combine, then strain into a rocks-filled tumbler, top with club soda to taste and garnish with orange twist.

*To make maple simple syrup, combine equal parts maple syrup and water in a saucepan and bring to a simmer over medium heat. Stir until maple dissolves and then remove from heat and cool. Leftover simple syrup will keep within a sealed container in the refrigerator for up to three weeks.

January Moon

This creamy drink will fortify you on an icy winter night.

ice
1½ ounces apple brandy
½ ounce crème de cacao
1 ounce whole milk
splash heavy cream
½ ounce maple simple syrup
dark chocolate, for shaving

In an ice-filled shaker, blend spirits with milk, cream and maple syrup. Shake until chilled and then strain into a martini glass. Shave dark chocolate over the top and serve.

in Barbados did not—they lived in sand crab–infested squalor, scrambling for provisions or work and staving off depression and hunger with cheap, copious rum, being a quick, cheap way to get sauced. Visitors to Barbados in the 1600s noted that the island's residents seemed perpetually drunk. Visitor Henry Whistler wrote in his journal in 1655, "This Illand is the Dunghill wharone England dost cast forth its rubidg: Rodgs and hors and such like peopel are those which are generally Broght here. A rodge in England will hardly make a cheater here."

What those "rogues and whores" sauced themselves up with was a much sharper precursor to the smooth, barrel-aged spirit that we know today. Early unaged rum was not softened by time in a barrel and simmered as it went down, and at upward of 100 proof, it got one drunk fast and without grace. Colonial-era rum lacked finesse and tasted like fire, a "hot, hellish and terrible liquor," according to English émigré Richard Ligon in 1651.

Rum probably first arrived in New England aboard one of the ships that carted sugar and molasses up to the colonies. Like Madeira, rum journeyed in barrels that lent it a golden hue and caramel-like flavors on arrival. By the 1650s, New England merchants were trading salted fish and lumber for hogsheads of rum, as well as molasses. The French were still heavily invested in bolstering their brandy industry and had little use for molasses, so sugar producers on French West Indian islands were happy to sell their molasses to American colonies at a snip, a price much lower than from sugar producers in the British West Indies.

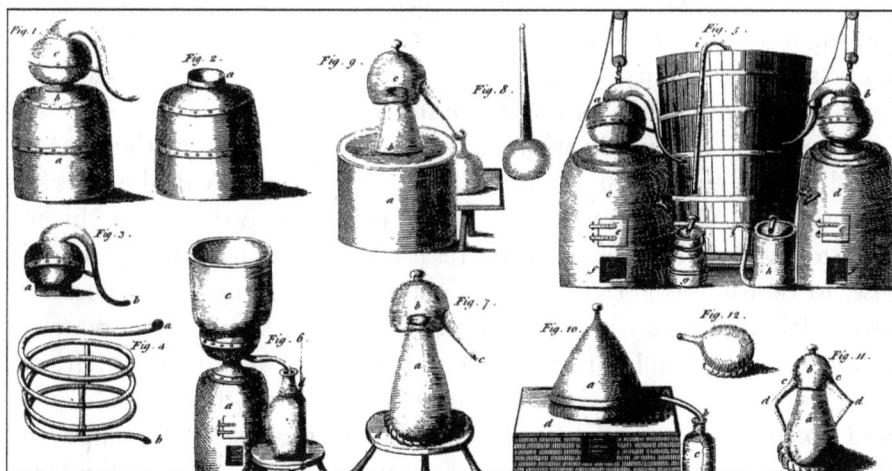

Drawing of stills from *The Complete Distiller* by Ambrose Cooper. *Cambridge University Library.*

Although some New Englanders used molasses as a sweetener, tons of the sticky stuff went into producing massive amounts of rum; rum distilleries sprung up along the coast like mushrooms after rain. On New York's Staten Island, a distillery opened in 1664 that eventually began producing rum. Distilleries also sprang up along the East Coast from Connecticut to Maine, with epicenters around Boston and Newport, Rhode Island. By 1687, Massachusetts was importing 156,000 gallons of molasses from the British West Indies alone, and Medford became known for the high quality of the rum made there. The hundreds of thousands of gallons that the colonies distilled in 1720 grew to just under 5 million gallons by 1765, pouring out of New England's 143 distilleries—on top of the 5 million gallons that were imported from the West Indies that same year. The price fell in tandem: between 1722 and 1738 alone, the cost of a gallon of rum in Boston went from three shillings and six pence to two shillings. By 1770, a gallon cost just over one shilling.

Who could drink 9 million gallons of rum a year? Colonists certainly could. Taverngoers had myriad ways for taking their rum, which got them drunk quicker (and for fewer coins) than cider, beer or certainly wine. Tavern records from Boston and across the colonies show that gallons of both West Indian and New England rum were taproom staples, and the drinks that creative barkeeps invented were precursors to the modern cocktail. They drank it straight (a dram); watered down (grog and sling); blended with pepper (pepper rum), cider (Stone-Fence) ale and cream (flip) or brandy (Rattle-Skull); or glugged into a bowl with citrus juices and sugar (punch). By the time Increase's son, Cotton, railed, "Would it not be a surprise to hear of a Country destroy'd by a Bottel of Rum?" his countrymen were fairly soaked in the stuff.

Although it was made with the same molasses used in the islands, no odes were ever written about New England rum. With the possible exception of Medford rum, the northern-made spirit had a thicker consistency and more savory taste. Yet it was still strong enough, alcohol-wise, to be used as currency in the colonies and across the Atlantic in Africa. Rhode Island distilleries became especially known for producing powerful, triple-distilled rum that could be traded on the West African coast for slaves. In this simplified triangle (and one that doesn't quite hold up to the historical record), West Indian molasses was shipped to New England for rum, strong New England rum was sailed to the West African coast for enslaved people and finally those slaves would be carted

back to the Caribbean to produce more sugar, molasses and rum. A journal entry from a Providence merchant named James Browne lays out what happened to some of the rum that his sloop *Mary* brought to the coast of Guinea: the rum was taken to Africa and traded for "men, women and children," who were then transported to the West Indies and sold for rum, gunpowder, salt, cordage and coffee. There were plenty of ships making at least one leg of this journey, but no records show any one company or ship working all three grisly angles.

The production of rum built great wealth in New England, making up 80 percent of all exports from the United States at the precipitous moment that British Parliament passed the Molasses Act in 1733, one of the first laws (which would also include the Townshend, Postal and Navigation Acts) that roiled the increasingly defiant colonists. The act introduced a six-pence-per-gallon tax on molasses from non-British islands, and it had powerful backers—namely, the West Indian sugar barons. Once the group had established massive sugar plantations and bought out small landholders on their respective islands, some returned to England to live on estates and command their sugar empires from afar. That involved constant vigilance to their own economic interests. For decades, the growers strong-armed Parliament to pass laws that protected those interests—including duties on goods that were imported into the colonies. In 1733, this cabal of producers pressured Parliament to pass that fateful Molasses Act, which intended to put the kibosh on molasses trade with the French West Indies and compel colonists to do business with British islands.

The opening shots of the Revolutionary War may have been forty years off, but the Molasses Act was one of the British legislative stumbles that set it into motion. Colonial distillers refused to obey the duty and began smuggling in molasses, utilizing the hundreds of discreet coves that littered the New England coast. They also resorted to bribes, offering money to British officials who might ignore the hogsheads of molasses that still arrived from Martinique and Guadalupe. Smuggling became rampant and commonplace, yet England seemed to turn the other cheek. In spite of the Molasses Act, the number of distilleries in Massachusetts grew from thirty-five in 1750 to sixty-three by 1774.

Although the wholesale ignoring of the Molasses Act by colonial New Englanders irked British authorities, they were distracted by other entanglements both at home and abroad. The Seven Years' War was remaking the world at large—its borders, its alliances and its coffers.

What was essentially the first world war pitted England, its colonies and Germany against France and its allies Sweden, Spain and Austria; it unfolded all over the world, from the colonial border with French Canada to the coast of West Africa. When it was over, Britain had gained a powerful global perch, yet its treasury was also empty. British legislators determined that since the war had been fought mostly in the service of the American colonies, it was the colonies that should be handed the bill.

In 1764, the English Parliament passed the Sugar Act, which actually halved the duty on imported molasses to three pence per gallon but called for stricter enforcement, including posting British ships at the mouth of ports to collect duties. For a society and merchant class that already felt buffeted by British duties and taxes—and powerless to fight them—it stoked the patriotic fire. Colonial protests were loud and brash enough to compel Parliament to lower the duty but not before some distillers lost significant profits; Britain customarily followed up with a volley of onerous acts that taxed tea and newspapers (in fact, all printed material). By the time shots were fired in Lexington in April 1775, bloody skirmishes had already broken out in Boston and Salem, and war's creeping shadow was engulfing the colonies and bringing molasses imports to a halt. Even after the war ended in 1783, the national taste for drink had shifted, and molasses was still hard to come by while the British and French West Indies were closed to American trade.

Rum distilleries would slowly grind into motion again after the war, but the spirit would never realize the frenzy of devotion it enjoyed before 1775. A more homegrown spirit would supplant rum as colonists' whetter of choice: whiskey.

WHISKEY

English immigrants may get props for settling New England, but hundreds of thousands of Scotch-Irish also arrived in the colonies during the 1700s. As people used to making do with less, they tended to push farther inland, past the Appalachian mountains to what was then known as the frontier: Pennsylvania, Kentucky, Ohio and western Virginia. And they brought with them their fondness for *uisce breatha*, the breath of life. Whiskey.

Whiskey had long been a part of daily life for Scottish and Irish people, who used barley and smoky peat-filtered water to make the spirit. Here, they didn't have access to the water that lent their native drink smoky flavor, but American soil was richer than the soil back home—ideal for growing grains such as rye, corn and occasionally barley.

Corn whiskey's roots in America go back to at least 1620, when Virginia colonist George Thorpe had an *a-ha* moment while distilling Indian corn into whiskey. "Wee have found a waie to make soe good drink of Indian corne I have divers times refused to drinke good strong English beare and chose to drinke that," he wrote to relatives back in England. By the mid-1700s, crude pot stills started becoming common through Pennsylvania, and the whiskey that poured from them ranged from clear and sweet (if distilled from corn) to sour (if distilled from barley).

Even before whiskey became synonymous with the frontier, though, it was produced in small quantities in places such as Boston and Philadelphia by families who used primitive tin stills to make what they called *usquebaugh*, cheaper than beer and five times as strong. Yet with rum in great abundance up until the time of the Revolutionary War, whiskey occupied a back seat until molasses and rum shortages during the Revolutionary War changed its fortunes. With the molasses and rum trade interrupted for eight years, thirsty colonists filled their glasses and mugs with more "indigenous" drinks such as cider, home-brewed beer and whiskey.

Although rum distilleries would slug back into motion after the war, whiskey was already on its way to becoming the quintessential American spirit, one produced in what then passed for the heartland. It would also bring about the new nation's first crisis.

Once the smoke had cleared from the Revolution, most of the colonies—now U.S. states—were deeply in debt. Trade routes with Britain and many Caribbean islands were cut off, and although America had long been used to importing more goods than it exported, the need for cash was powerful and obsessed the country's new lawmakers. How to refill the country's coffers inspired long, intense debates in the new Congress, where Secretary of the Treasury Alexander Hamilton argued that an excise tax on whiskey was the choicest way. His ideas were opposed by congressmen such as Thomas Jefferson. Although popular and legislative support for a whiskey tax waxed and waned, it eventually gained steam via a cabal of doctors and scientists led by anti-alcohol

crusader Dr. Benjamin Rush, who proclaimed that whiskey—and all ardent spirits—was corrosive to the human body and soul, as well as a threat to the new republic's health. In a 1790 United States Senate hearing, physicians claimed that whiskey was ruinous:

It belongs more peculiarly to men of other professions to enumerate the pernicious effects of these liquors upon morals and manners. Your memorialists will only remark that a great proportion of the most obstinate, painful, and mortal disorders which affect the human body are produced by distilled spirits; that they are not only destructive to health and life, but that they impair the faculties of the mind, and thereby tend equally to dishonor our character as a nation, and to degrade our species as intelligent beings.

A tax on whiskey finally went through in 1791: distillers would be taxed four pence for each gallon of whiskey that flowed from their stills, whether it was intended to be sipped at home or sold at retail.

For frontier dwellers with fiery Scottish and Irish blood in their veins, the tax was an affront. The new federal government was hundreds of miles away, and they puzzled over how legislators could tax them from afar, much as the English had done before them. The law called for the tax to be paid to collectors in actual currency, which was a conundrum because whiskey often *was* the de facto currency in Pennsylvania, where coins and paper money were scarce. Farmers paid their rent *and* their field hands with whiskey, and the spirit was also traded for coastal commodities such as salted fish and metal.

Resistance was swift and fierce. The men of western Pennsylvania took up muskets to defend their rights to use their own grain and their own stills to make as much whiskey as they liked free from an ill-conceived tax. Hundreds of men—farmers, writers and lawyers among them—began harassing tax collectors, burning down their houses and using tar and feathers to humiliate them.

For new president George Washington, this could not stand. When negotiations with the rebels failed, Washington personally led thousands of militiamen to western Pennsylvania in 1794. They arrested some rebels, and the rest scattered or ended their violence.

Whiskey had left an impression on Washington, though. After the dust had cleared and George had handed over the presidential reins in 1797,

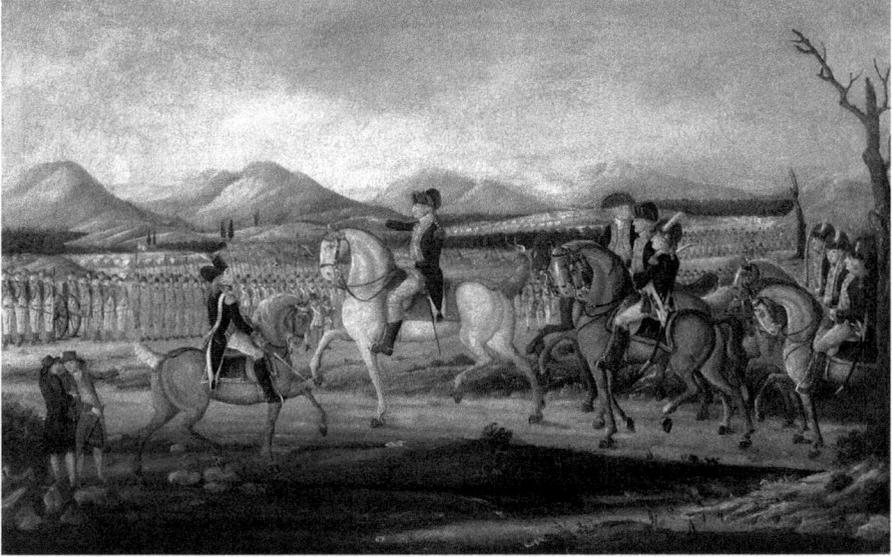

George Washington and his troops near Fort Cumberland, Maryland, before their march to suppress the Whiskey Rebellion in western Pennsylvania. Painting circa 1795, artist unknown. *Wikimedia Commons.*

he returned home to Mount Vernon and promptly had some whiskey stills constructed. His staff produced 600 gallons in 1797; one year later, they upped that to 4,500 gallons and then 11,000 gallons the next. By the time Washington died in 1799, he was one of the nation's preeminent distillers of white dog whiskey.

He was the first of a wave. Far from the frontier, in New England, whiskey distilleries sprang up—even relatively temperate Vermont had 125 distilleries by 1810—and towns such as Peacham became known for what they called "potato rum" (aka whiskey made from a potato mash, which sold for fifty to seventy-five cents per gallon and was shipped across the border into Canada). Whiskey even edged out maple syrup as a product in 1810, outpacing sales by $7,000. As a Peacham historian wrote, "There was probably never a period in the history of the United States when a man could get drunk more easily or at less expense than in the first three decades of the nineteenth century."

Part 4

HOW THEY DRANK

With their small culinary arsenal of rum, cider, ale, sugar, molasses, eggs, spices and citrus, colonial drinkers came up with a baffling variety of drinks. Although their larder was limited and the drinks sometimes sound crude (how can rum dropped into a pint of ale possibly taste good?), some of their simple concoctions were surprisingly delicious. Yet because they tended to be drawn from shifting combinations of the same ingredients, the distinctions between one drink and another can be faint, hinging solely on a slight alteration in the amount of water, spirit, citrus or spice used. For example, a Calibogus combined rum, ale and molasses, but so, too, did certain versions of flip. A posset that combined sack and cream doesn't sound much different (on paper at least) than a syllabub, which blended white wine, cream and egg whites. And certain punches were virtually indistinguishable from sangaree, which was wine-based.

Some of these drink names have been recorded in the stained, crumbling ledgers of old taverns, inked in lilting handwriting that catalogues not only gills of brandy and rum but also mugs of grog, punch, sling and flip, plus rough-and-ready drinks with even more musical names—cherry bounce, manathans and Bombos among them. Many of these drinks persisted (and even flourished) after the war, especially as barkeeps began to add ice to drinks. In the early nineteenth-century Claremont, New Hampshire tavern of David

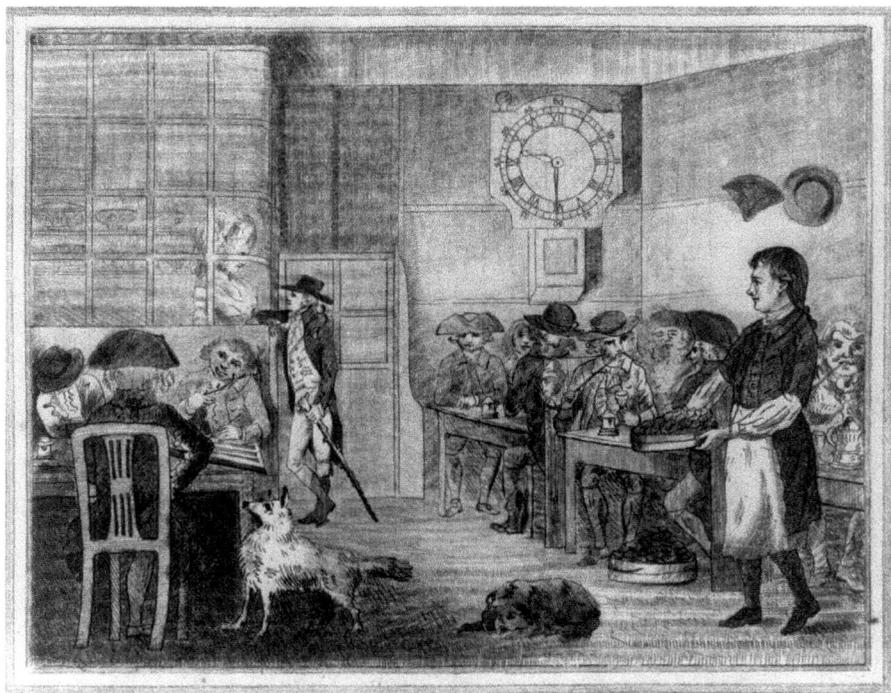

Gray's Inn Lane. *Library of Congress.*

Sumner, customers were still ordering a ton of flip, as well as pints of gin, gills of wine and mugs of "cyder."

When possible, I offer as historically accurate a colonial version of the drink as I could find—sometimes verbatim—as well as modernized takes using present-day ingredients. These are mostly as simple as possible so that the amateur home drinker can experiment without breaking the bank or spending hours searching for (or making) obscure liquors and cordials (although if Ratafia intrigues you, go for it). Experienced bartenders (and I consider myself an amateur) can use the recipes as templates. However, even novice mixologists should acquaint themselves with bitters, which were sipped straight in colonial times but, when dashed into drinks, add a layer of complexity. And where colonists used molasses, a simple syrup might do; as its name suggests, it's easy to make, and it's a key and versatile ingredient when mixing drinks.

As they bellowed inside Abbot's Tavern in the year of our Lord 1765, "To the king's health!" Or rather, to yours.

Applejack, Apple Brandy and Cider Royal

Hard cider, the stuff of so many colonial tankards, had its more bracing counterparts—such as applejack, which was born of a freeze distillation process called jacking. Since water freezes quicker than alcohol, cider left outside during a frigid New England night would form a layer of ice on top of concentrated alcohol that's sweeter and sharper than cider and upward of 60 proof. Like other spirits, applejack was sometimes used as colonial currency—especially in New Jersey, an applejack epicenter where the liquor was used to pay laborers of all stripes.

Whereas applejack could singe the throat and sucker-punch the liver, apple brandy appealed to more refined tastes. Letting pressed apple juice ferment, distilling the result two or three times and then letting it age in barrels yields a russet-colored apple brandy that at its best is silky and smooth, with layers of caramel and vanillin smoothing out its edges. After the war, Vermont was a hotbed of apple brandy production, turning out 173,000 gallons of the stuff from 125 distilleries by 1810.

If they added some apple brandy to cider and let it meld together in a hot place, thirsty colonists would soon be enjoying a cider royal, a fortified cider that wouldn't spoil as easily as its lower-alcohol forebear. For visual drama, cider royal was sometimes produced in bottles that had been placed onto the ends of apple tree branches when the fruit was still small enough to fit inside the neck; as the apples grew, they would fill the bottles and make picturesque vessels for the later addition of cider royal. (Colonists also used this method for bottling pear brandy, aka perry.)

Applejack wasn't sold much in colonial taverns, at least according to ledgers; it was a drink imbibed at home or by the farmers who made it. Apple brandy, though, was more common in public houses, and its price sometimes fell between that of beer and metheglin.

After the temperance movement, applejack and apple brandy fell from grace, with the exception, perhaps, of French-made Calvados. Yet like most New England spirits, apple brandy is having a renaissance from the shores of Lake Champlain down to the coves of Maine. Orchardists who began producing hard cider in recent years are also testing the waters of barrel-aged apple brandy—places such as Shelburne Orchards in Vermont (which calls its version Dead Bird) to Bartlett's Estate Winery in Maine.

It's technically illegal to make your own applejack, but it plays very well in cocktails. Here are two recipes for apple brandy drinks—one cold, the other decidedly for winter.

Traditional: Cider Royal

If you'd like to make Cider Royal the truly traditional way—and you have access to an apple tree—find a half-sized wine or Champagne bottle, slide a young apple still on the branch through its neck and tie the bottle to the tree so that it stays there until harvest time. Otherwise, just grab a sanitized 750-milliliter bottle that can be tightly corked.

½ cup apple brandy
1 750-milliliter bottle of hard cider

Blend brandy and cider in a sanitized bottle and cork tightly. Place in a hot place for 3–6 months to combine.

BITTERS

A farmer knocking back a dram of tansy bitters on a cold 1754 morning might have been puzzled to learn that a century later, his morning jumpstart would be adopted as a cocktail ingredient in an 1890s hotel bar or, even later, by suspendered mixologists in the nether parts of Brooklyn. For early Americans, "taking some bitters" was a daily morning ritual, and within reach of the breakfast table were tiny vials of booze—often Madeira, rum or brandy—infused with medicinal barks and roots. Those bracing a.m. shots might be flavored with anything from juniper berries, mint and dried orange peel to spicebush berries and mugwort (aka tansy). These were thought to stimulate the digestive system and, in the southern colonies, to ward off malaria.

As with most of their liquids, colonists gave bitters a mélange of entertaining names—whiskey skin, fogcutter and timber doodle along

them. Bitters were usually homemade, although some commercial versions were imported from England from the early 1700s on. Stoughton Bitters was an enormously popular brand made with wormwood, gentian, cascarilla, rhubarb and orange peel; once the Stoughton recipe was published, dozens of other companies joined the fray, including Angostura, which was founded in Trinidad in 1824 and whose spicy, super-secret blend still ranks as the most popular bitters in the world.

Although they're not a traditional colonial cocktail ingredient, bitters are simple to make at home. Practically any botanical, dried fruit or herb can be commandeered for bitters: lemongrass, cola nuts, rhubarb, hibiscus, dandelion and more. Marry them with alcohol, let them steep for a few weeks and they're ready to use. Taken straight, they offer a direct sensory connection back to a typical colonial morning. Used in a cocktail (a few of them in this book call for bitters), they add subtle complexity.

Traditional: Basic Bitters

Adapted from various sources.

¼ cup of bitter and dried bark, fruit, herbs, seeds or roots (clove, allspice, orange peel and angelica will hew closely to colonial-style bitters)
a sanitized jar with lid
1 cup grain alcohol, such as Everclear or vodka

Add bark, fruit, herbs or all three to a jar and pour alcohol over the top. Seal tightly and stash away in a dark place for 2 weeks, gently shaking the jar once each day. After 2 weeks, taste the bitters to ascertain whether they're as strong as you'd like them to be. When they're ready, strain the alcohol through a cheesecloth, pressing to remove every trace of flavor. Decant bitters into a sterile eyedropper jar and seal tightly. They will keep for up to a year.

Modern: Bitter Sparkler

Whether you're set with either your own bitters or using a store-bought version, this classic aperitif will showcase their flavor—whether spicy, fruity or floral.

1 sugar cube
1–2 dashes of bitters
Champagne

Place sugar cube into a Champagne flute and dribble a dash or two of bitters onto its top. Fill the glass with Champagne and serve.

CALIBOGUS

This funky, refreshing drink—sometimes known as a bogus—blends spruce beer, molasses and rum into something that tastes like it was born in the crook of a pine tree. It was popular with colonial-era sailors tying one on in New England ports, as well as those who didn't much care that it sometimes called for sour beer. Although Calibogus was usually served warm, I've tried it both ways and find it more delicious (and refreshing) as an ice-cold drink. Use the darkest rum you can get your hands on.

Traditional: Calibogus

This recipe is adapted from the invaluable book *Wines & Beers of Old New England*, and although the drink was often served warm, this works better chilled.

dollop of molasses
1 ounce dark rum, such as Cruzan
6 ounces spruce beer (see note below)
spritz of fresh lime (optional)

Add molasses and rum to the bottom of a pint glass and stir vigorously to combine. Top the glass with spruce beer. Stir, add a spritz of lime if desired and serve.

Note: In colonial days, brewing with spruce tips (in lieu of hops) was common, but spruce beer could also be a non-alcoholic drink sold from carts, alongside birch beer. Several New England craft brewers produce a version of spruce beer, such as Candia Road Brewing Company in New Hampshire (its version is called Nepenthe Ales Picea).

CHERRY BOUNCE

Early Americans imbued their beloved drinks with irreverent and often vivid names. Case in point: cherry bounce, made by dropping fresh sour cherries into your spirit of choice (usually brandy or rum), adding some sugar and patiently waiting for the fruit's juices to infuse the drink.

Cherry bounce was a favorite libation of Martha Washington, as well as her husband, George, who carted a canteen of it with him to Pennsylvania during a postwar journey. It's best sipped at room temperature, although it responds kindly to some ice and a splash of sparkling water.

Traditional: Excellent Cherry Bounce (Courtesy of Martha Washington)

Extract the juice of 20 pounds well ripend Morrella [aka sour] cherrys. Add to this 10 quarts of old french brandy and sweeten it with White sugar to your taste. To 5 gallons of this mixture add one ounce of spice such as cinnamon, cloves and nutmegs of each an Equal quantity slightly bruis'd and a pint and half of cherry kirnels that have been gently broken in a mortar. After the liquor has fermented let it stand close-stoped for a month or six weeks then bottle it, remembering to put a lump of Loaf Sugar into each bottle.

Ebulum

Before there was elderberry cordial and St. Germain, there was ebulum—ale flavored with the juice of elderberries and a touch of juniper essence.

Ebulum was created by Welsh Druids in the ninth century, who began adding the elderberries that they used medicinally to ale they sipped during harvest festivals. The Druids, in turn, introduced ebulum to the Scottish Highlands, where it became part of that country's brewing landscape. Since elderflower also grows prolifically in America—and early Americans were enthusiastic about using most anything to flavor their beers—ebulum began appearing in early colonial taverns. At the Old Ordinary in Hingham, Massachusetts, built in 1688, ebulum shared the taproom along with the requisite beers and rum drinks, according to an account by a taverngoer named Miss Russell.

A few craft breweries here and in the United Kingdom still make their own versions of ebulum, often adding the berry essence to a black ale made with lots of roasted malt. In Washington, D.C., a recently shuttered eatery called America's Tavern created its own twist on ebulum using gin, lemon, cider and elderflower.

Flip

The days are short, the weather's cold,
By tavern fires tales are told.
Some ask for dram when first come in.
Others with flip and bounce again.
—New England Almanac, *December 1704*

Variations: Bellow-Stop, Yard of Flannel, Hotch-Pot, Crambambull

The 1890s had the gimlet. The 1990s had the Cosmo. In the 1690s and even the 1790s, it was creamy flip that ruled the bar, a drink that sated potato farmers and judges, parsons and paupers, and drew on fire for its distinctly singed character.

Right: A classic flip. *Author photo.*

Below: A flip mug from Pitt's Tavern, Portsmouth, New Hampshire. *Author photo.*

Flip was a blend of beer; rum; a sweetener such as molasses, sugar or dried pumpkin; and occasionally eggs and cream. It was often mixed in a pitcher, spiced with nutmeg and then heated and singed by plunging a hot fire poker (often called a flip-dog) into the middle of the drink. The poker would whip the entire thing into a froth—adding earthy, burnt flavors—and then the barkeep would decant portions into ceramic flip mugs.

Although flip was born in England, it was a uniquely American touch to heat it with a fire iron instead of a saucepan. Once flip began appearing in taverns in the 1690s—coinciding with Americans' growing lust for rum—it would capture the colonial drinkers' hearts and livers for a century to come.

The composition of flip varied from tavern to tavern, and so sometimes did its name. Whole eggs were not always part of the drink, but when they *were* added, the drink was sometimes called a Bellow-Stop or a Crambambull. Similarly, a blend of warm beer and rum was not always called a flip; the name Hotch-Pot was used for essentially the same drink, albeit sans spices. Calibogus—that blend of rum, spruce beer and molasses—was also served warm but differed from flip because of its slightly different base.

The most vaunted flips were rendered velvety by pouring the drink several times between two pitchers until well blended. Some taverns drew robust trade based on their flip recipes. At Fraunces Tavern in New York City, where George Washington gave the farewell speech to his soldiers after the war, the barkeeps served up a variation called a "Yard of Flannel"—warmed dark ale, eggs, sugar, rum and nutmeg. At Abbot's Tavern in Holden, Massachusetts, which opened in 1763, a flip might set you back a bit during the Revolutionary War. A bill of fare intimates that the pleasures of the tavern's flip were far superior to its sleeping arrangements:

Mug New England Flip—9D
Mug West India Flip—11D
Lodging Per Night—3D
Pot Luck Per Meal—8D
Boarding Commons Men—4S 8D
Boarding Commons Weomen—2S

In the Canton, Massachusetts May's Tavern, which operated throughout the 1700s, the town historian recorded its "delicious" flip recipe in 1893. His notes aim to "reveal the mystery of its decoction"—a bit of fermentation, it seems:

> *Four pounds of New Orleans sugar, four eggs, and one pint of cream were thoroughly mixed and allowed to stand two days; then when the anxious customers appeared, a quart-mug nearly full of beer was drawn, and four large teaspoonfuls of the compound put into the beer; then the loggerhead, well heated, was applied to each mug, then one gill of rum added to each mug; and the work, as far as the landlord was concerned, was completed. All that remained was to uncover, and drink the king's health.*

Traditional: Flip

This recipe appeared in the meticulously researched *Stage-Coach and Tavern Days*, written by Alice Morse Earle in the early 1900s:

> *Keep grated Ginger and Nutmeg with a fine dried Lemon Peel rubbed together in a Mortar. To make a quart of Flip: Put the Ale on the Fire to warm, and beat up three or four Eggs with four ounces of moist Sugar, a teaspoonful of grated Nutmeg or Ginger, and a Quartern of good old Rum or Brandy. When the Ale is near to boil, put it into one pitcher, and the Rum and Eggs, etc., into another: turn it from one Pitcher to another till it is as smooth as cream. To heat plunge in the red hot Loggerhead or Poker. This quantity is styled One Yard of Flannel.*

GROG

Almost as soon as rum barrels began rolling into the colonies, barkeeps, farmers and drinkers began diluting the spirit with water. This served multiple purposes: it made the fiery spirit smoother to drink, it weakened

rum's strength for those who sipped it throughout the day and it stretched a barrel that much further. Precisely *how* much water was added to rum made a difference—for instance, equal parts rum and water made a sling; two parts water to one part rum was called grog.

It was the British who formalized grog. For years, Royal Navy sailors were given daily rations of beer while at sea—up to a gallon each day. In 1655, when Britain conquered Jamaica, the navy wove Jamaican rum into sailors' daily rations. That became a daily half pint of rum in 1731, served once in the morning and again in the evening.

Since sipping straight rum could render sailors rowdy, navy admiral Edward Vernon suggested in 1740 that sailors' daily rum be watered down and flavored with sugar, fresh lime juice and sometimes cinnamon. The resulting drink became a bastardization of Vernon's nickname ("Grogram"), a proto-cocktail that persisted aboard British navy ships, in declining amounts, until it was abolished in 1970.

At its most basic, grog is a blend of one part rum to two parts water, with the addition of citrus juices and a sweetener. Like the ginger in switchel, citrus juices not only masked foul water or rum but also delivered vitamin C to sailors while they were at sea, warding off scurvy during ocean crossings.

Despite the seeming simplicity of grog, the term "grogshop" was a denigrating term in colonial New England, usually used to describe rough-and-ready taverns where people and other riffraff might drink cheaply for hours, the equivalent of the modern dive. Boston was peppered with grogshops from the 1700s on (they peaked in the early 1800s), while the Doty Tavern in Ponkapoag, Massachusetts (now Stoughton), was said to have the best grog in the colonies. Although the exact proportions of the recipe are lost, it was Colonel Tom Doty's grog that Sam Adams and Dr. Joseph Warren were supping on when they met with citizens at the tavern on August 16, 1774, to pound out the Suffolk Reserves, a precursor to the Declaration of Independence. Just after the Revolutionary War, a former captain named William Bent was also rumored to serve a mean grog at his Canton tavern, the Eagle Inn.

Colonists drank their grog at room temperature, but don't attempt this unless you have a truly stalwart New England constitution.

Traditional: Grog

2 ounces rum
4 ounces water
½ teaspoon superfine sugar
ice
½ ounce lime juice

In a tumbler, stir rum, water and sugar and stir until sugar dissolves. Add ice and a spritz of lime juice and stir to combine.

Modern: Midnight Grog

This sweet-and-sour cocktail does call for a few offbeat ingredients but draws tartness from rosehip simple syrup and a layer of smoke from the blackstrap rum. A splash of Chartreuse lends brightness and hints of herbs.

ice
2 ounces blackstrap rum
½ ounce orange liqueur (such as Cointreau)
1 teaspoon rosehip simple syrup (recipe on page 103)
½ teaspoon fresh-squeezed lime juice
dash of orange bitters
dash of Chartreuse

In a shaker filled with ice, add rum, orange liqueur, simple syrup, lime juice and bitters. Shake hard to combine and then strain into a coupe glass. Dribble Chartreuse on top, as a float, and serve.

Mimbo and Bombo

Combining crunchy consonance with a healthy splash of rum, a Mimbo was a blend of dark rum, a shave of brown sugar (called "loaf" back in the day) and water. The deceptively simple result is oaky and subtly sweet, an ideal dram for a late fall night—and much different from what's called a Mimbo in Cameroon, a type of palm wine. In the taverns of York County, Pennsylvania, in 1752, the price of a quart of Mimbo was set at nine shillings if made with New England rum and ten shillings if blended with West Indian rum. In New Jersey two decades earlier, asking for muscovado sugar would land you a slightly cheaper Mimbo.

Shave some nutmeg over a Mimbo, and it becomes a Bombo.

Traditional: Mimbo

1 teaspoon dark brown sugar
2 ounces dark rum
splash of cold water

In a tumbler, add sugar and then rum. Stir vigorously until sugar is dissolved. Add splash of water and serve.

Modern: Cherry-Mint Mimbo

It's hard to improve on the simple contours of a Mimbo. It *really* is good. Carbonation destroys it (both soda water and bitter lemon fail miserably), while adding citrus turns it into an entirely new creature. In the end, a brown sugar simple syrup helps evenly distribute the sweetness, and a dash of cherry bitters adds a note of dark fruit.

1 teaspoon brown sugar simple syrup* (or substitute regular brown sugar)
2 ounces dark rum
dash of cherry bitters
splash of cold water

ice
mint for garnish
scrape of nutmeg (optional)

In a tumbler, add simple syrup, rum, cherry bitters and water and swirl to combine. Add ice, garnish with mint sprig and serve. Shave a touch of fresh nutmeg over the top to turn it into a Bombo if you'd like.

To make brown sugar simple syrup, slowly heat equal parts brown sugar and water in a saucepan until sugar dissolves. Let cool and decant to jar. The syrup will keep for up to two weeks in the refrigerator.

POSSET AND SYLLABUB

For centuries, booze has been used to stave off colds and illness, for better or for worse; when it's combined with cream, its healing powers are thought to double. That might explain the enduring popularity of posset, a European drink that was imbibed as early as the fourteenth century and eventually grew into what we know as eggnog. At its most basic, a posset is made by bringing milk to the brink of boiling and then blending it with an equal measure of ale and sometimes a dash of lemon juice, causing it to curdle. Sometimes beaten eggs were added before the drink was showered with grated nutmeg and spices.

The technique is somewhat similar to that of making ricotta cheese, and the taste and texture are similar, too. Basically, drinking a posset is sort of like drinking custard. In colonial New England, though, possets weren't synonymous with Christmas. Instead, they were a popular drink at weddings and other large celebrations, when huge bowls of posset were set out to sate guests—snow-white, creamy and a little bit tart.

When wine or cider was used instead of ale, it was called syllabub. (Except for sack wine, which gave rise to sack posset. Confusing much?) Like posset, syllabub has its roots in England, where it began at the tit: fresh milk would be decanted from a cow's udder into a bowl and then blended with ale and sometimes eggs and served as a custardy dessert.

Traditional: Posset

This recipe is taken from Eliza Smith's *The Compleat Housewife*, published in 1742. Although Smith was English, it was the first cookbook to be published in America:

Take a quart of cream, and mix it with a pint of ale, then beat the yolks of ten eggs, and the whites of four; when they are well beaten, put them to the cream and ale; sweeten it to your taste, and slice some nutmeg in it; set it over the fire, and keep it stirring all the while; when it is thick, and before it boils, take it off, and pour it into the bason you serve it in to the table.

Traditional: Syllabub

This renders enough syllabub for two.

2 cups full-bodied white wine, such as Chardonnay
¼ cup lemon juice
¾ cup superfine sugar
I cup milk
I cup heavy cream
2 egg whites
scrape of nutmeg

In a mixing bowl, blend the wine and the lemon juice. Add ½ cup of the sugar to the bowl and stir to dissolve. Pour milk and cream into wine mixture and beat until thick. In a separate bowl, beat egg whites with remaining ¼ cup sugar until stiff. Decant wine mixture into two mugs and spoon egg whites over the top. Grate nutmeg over the top and serve.

Punch

Boy, bring a bowl of China here,
Fill it with water cool and clear;
Decanter with Jamaica ripe,
And spoon of silver, clean and bright,
Sugar twice-fin'd in pieces cut,
Knife, sieve, and glass in order put,
Bring forth the fragrant fruit, and then
We're happy till the clock strikes ten.
—*Benjamin Franklin,* Poor Richard's Almanack, *June 1737*

I was once browsing a Long Island antique store when I came across an ornately engraved copper punch bowl. As I leaned in to examine it, the store owner appeared and ran her finger along the rim. "Isn't it stunning?" she gushed. After looking lost in reverie for a moment, she said earnestly, "No home should be without a punch bowl." I searched her face for a trace of irony, but she was grave—and would have been historically accurate if she had changed the word "home" to "tavern."

What to me seemed like a rarified relic of a long-forgotten time was actually a colonial bar staple long before it became a fixture of polite society. Bowls of citrusy rum, brandy and Madeira punches were social lubricants inside public houses, at dinner parties and even during serious deliberations—but only for men of a certain class. While poorer New Englanders were swilling rum mixed with water—grogs, slings, toddies, flips and Mimbos—gentlemen of means took their rum and Madeira blended with lemons, limes and oranges; with milk and tea; and with cinnamon and nutmeg. They cemented their friendships over sips and mugs of punch drawn from the same bowl.

Punch was not a native creation; it had traveled halfway around the world to take its place at the colonial table. From India, specifically, where the Hindi word *panch* (which means "five") describes the number of ingredients blended in this staple of Indian culture. Indians often combined *arrack*, a spirit distilled from the sap of palm trees, with lime, sugar, water and spices. This was called *paantsch*, and it bled into European society via officers of England's East India Company, who transported the practice of punch-making back to England in the mid-1600s. French

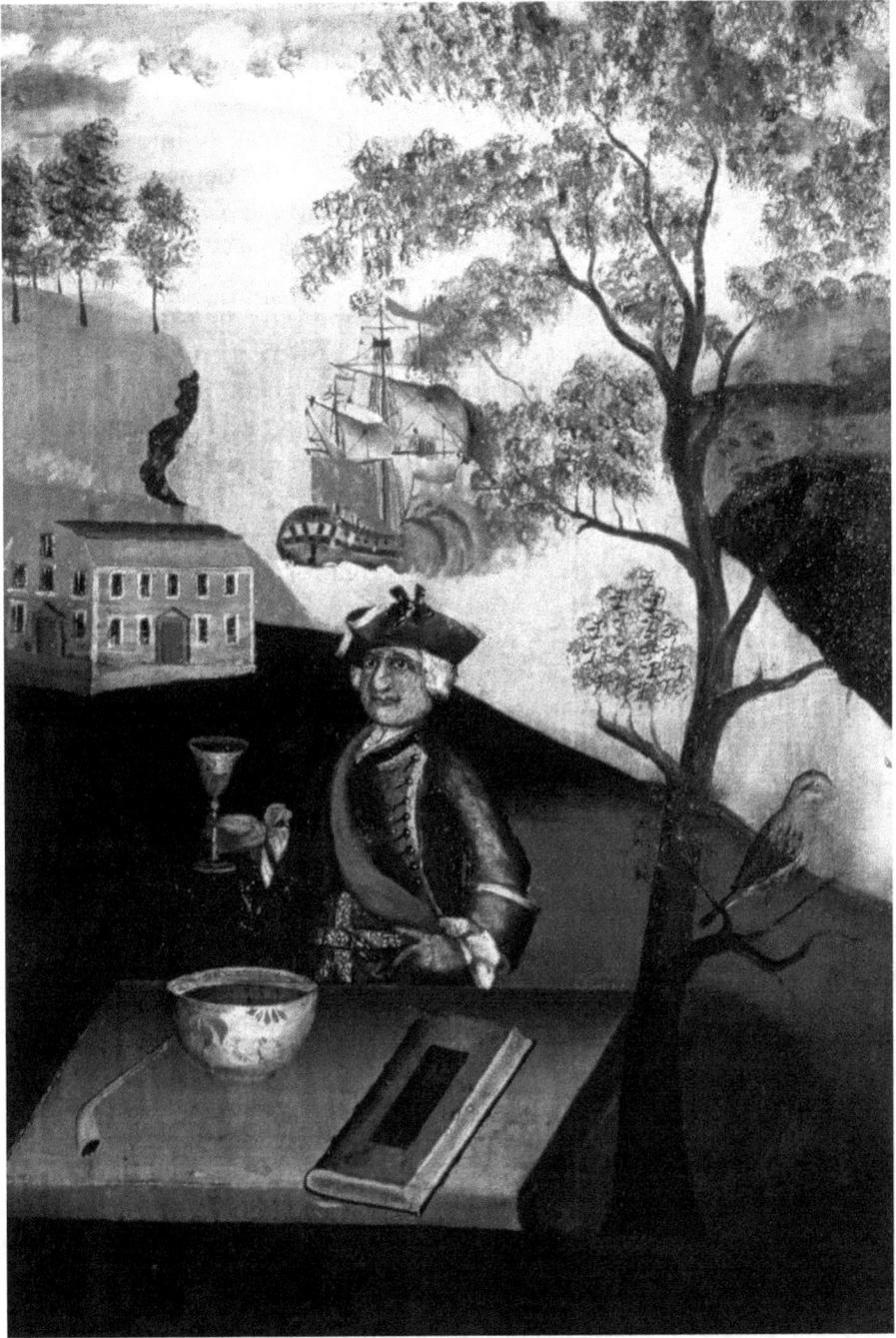

Moses Marcy Over Mantle. *Collections at Sturbridge Village.*

brandy and Spanish sherry were the base spirits of choice for English punch, which was blended in open-mouthed bowls like the one I saw that day on Long Island.

As the rum trade grew, Americans glugged it heartily into their own punches. As thirst for the drink grew, so, too, did the demand for citrus, which wasn't always available. In a 1741 ad from the *Salem (MA) Gazette*, fruit importer J. Crosby advertised, "Extraordinary good and very fresh Orange juice which some of the very best Punch Tasters prefer to Lemmon, at one dollar a gallon. Also very good Lime Juice and Shrub to put into Punch at the Basket of Lemmons, J. Crosby, Lemmon Trader."

Enormous quantities of spirits were used in punchbowls, and taverns kept gallons of lime juice and cinnamon water on hand for flavoring their punches. Punch-making rituals varied from tavern to tavern, from rubbing the peels of lemons with sugar to extract their oils to using hot tea to dropping a biscuit into the punch. When punch was served, it was drunk communally, with each imbiber taking a sip from the enormous bowl and then passing it around to his neighbor. Sometimes it was decanted into handled punch cups. Either way, the drinking of punch fostered fellowship and democracy, and it was swilled in enormous quantities. At the 1785 ordination of a Beverly, Massachusetts minister, the eighty attendees drank seventy-four bowls of punch, as well as twenty-eight bottles of wine and eight bottles of brandy.

Punch enthusiasts had their favorites. Captain Francis Goelet, a merchant from New York City, called the Bunch of Grapes "the best punch house in Boston," which enhanced that pub's already solid mystique. The place also had "salmon in season, veal, beef, mutton, fowl, ham, vegetable, and pudding, with a pint of Madeira before each partaker."

In the last few years, cocktail historians and mixologists have been reviving punch, and there are a clutch of excellent punch-related books worth seeking out for modernized recipes.

Traditional: Drink for the Summer

The quantity of alcohol in this sherry-Madeira punch, from the 1819 *Family Receipt Book*, speaks volumes about the capacity of early American livers:

Take one bottle of sherry (but Madeira is preferable), two bottles of cyder, one of perry, and one gill of brandy; and after those ingredients are mixed, take two lemons, pare the rind as thin as possible; then slice the lemons, and put the rind and lemons into a cup; to these add a little grated nutmeg and powdered sugar, to make it palatable; stir them together; then toast a biscuit very brown, and throw it hot into the liquor. It is generally found a pleasant draught at dinner, and produces no bad effects on those who drink it in moderation.

RATAFIA

Ratafia's roots stretch back to medieval France, when a splash of unaged brandy added to pressed wine juice and then combined with the kernels of cherries or peaches, some lemon peel and sugar became Ratafia. After being left to macerate for weeks, the cordial was sipped as an aperitif.

Although the cordial was of Mediterranean origin, it became especially popular in the southern colonies. A South Carolina resident named Eliza Lucas Pinckney wrote out her Ratafia recipe in 1756, and it included seventy-five peach kernels, two cups of brandy, half a cup of sweet wine, half a cup of orange flower water and half a cup of sugar.

Elsewhere, scrappy colonial residents might use sour or black cherries, juniper berries and even coffee beans to flavor their Ratafia. The entertaining 1831 book by Colin MacKenzie, *Mackenzie's Five Thousand Receipts in All of the Useful and Domestic Arts*, postdates the colonial period but is chock-full of exotic Ratafia recipes that draw on coffee beans, Seville oranges and "Florentine orris root." The two relatively sedate versions on the following page are more doable by the average home cook. Use sterilized glass jars, and for chocolate Ratafia, simply draw on good-quality cocoa beans.

Ratafia is an excellent mixer when combined with sparkling wine or soda.

Traditional: Ratafia des Cerises

Take of morello cherries, with their kernels, bruised, 8 lbs.; proof spirit, 8 pints. Digest for a month, strain with expression, and then add 1½ lbs. sugar.

Traditional: Ratafia de Chocolat

Take of Caracca cocoa nuts, roasted, 1 lb.; West Indian ditto, roasted ½ lb.; proof spirit, 1 gallon. Digest for a fortnight, strain, and then add sugar, 1½ lbs.; tincture of vanilla, 30 drops.

RATTLE-SKULL

Professional drinkers know that more than one Boilermaker (a shot of whiskey chased with a pint of beer) will knock you sideways. In colonial New England, taverngoers didn't bother with keeping the two alcohols apart—they tossed a mix of intoxicating liquors together into the most bracing of bracers, the Rattle-Skull. Although this blend of dark beer, rum, lime and nutmeg didn't differ much from the other rum drinks of the day, it packed a wallop from its proportions: four or five ounces of hard liquor dropped into strong, dark beer. It's dangerously smooth. If you'd like to try one on for size, do it at home...alone...when you're sure that bedtime is nigh.

Traditional: Rattle-Skull

pint of porter or other dark beer
¾ ounce rum
¾ ounce brandy

3 ounces sherry, or sack
spritz of fresh lime juice (optional)
scrape of fresh nutmeg (optional)

Fill a pint glass three-quarters with dark beer. Add rum, brandy and sherry and then stir to combine. Spritz with lime juice and top with nutmeg if desired or dispatch with such decorum and simply get saucy.

SANGAREE

Many colonial-era drinks were prototypes for later cocktails—eggnog evolved from posset, Hangman's Blood from Whistle-Belly Vengeance and sangria from sangaree. Sangaree is a spicy wine-based punch that originated on London's Strand in the 1760s with a street vendor who hawked a bracing, Madeira-based punch the color of blood—*sangre* in Spanish. Likely, though, this mythical merchant was but one step on the sangaree timeline from Spain to the West Indies, where it became a popular drink that usually consisted of a fortified wine such as Madeira or port, lemon juice, sugar and spices—essentially the cold version of mulled wine.

Traditional: Port Sangaree

4 ounces ruby port
2 thin lemon wheels
I teaspoon superfine sugar
scrape of nutmeg

Shake first three ingredients well with cracked ice and then pour unstrained into a tumbler or coupe glass and grate a little nutmeg on top.

SLING

Lest one think that a sling was famously invented in the bar of Singapore's Raffles Hotel in the early 1900s, slings were actually showing up in colonial tavern records by the late eighteenth century. By 1805, an innholder by the surname of Putnam was serving "mugs of sling" daily inside his rural tavern in Claremont, New Hampshire, suggesting that slings were around long before the era of hotel bars and even before the Revolutionary War.

Essentially a one-to-one blend of water and spirit (often rum or brandy) with a touch of sugar and citrus, a sling was simple yet bracing, the splash of water softening the spirit's hard edges. It was also considered slightly more refined to drink than straight rum or brandy.

Like punch, a sling draws its appeal from the interplay of sour and sweet flavors; the difference is that it was prepared in single servings and chilled with ice, once ice began appearing in glasses come the early 1800s. A variation of the sling was sometimes called a mamm.

STONE-FENCE

Ethan Allen certainly didn't require liquid courage, but the night before he and his Green Mountain Boys headed to Fort Ticonderoga, that's just what he sought. Stone-Fences were a bracing blend of hard cider and dark rum, and Allen and his men—including Seth Warren and Benedict Arnold—downed plenty of them in the hours before their predawn raid on heavily armed Fort Ticonderoga in May 1775, two weeks after the showdown on Lexington Green.

Although Allen and his crew usually hung their caps forty-seven miles south at Bennington's Catamount Tavern—marked by a stuffed catamount on a stick outside the front door—the whole of the New Hampshire Grants (as Vermont was then known) was their turf, and they were well versed in roaming its hills to fight the flatlanders from New York (aka Yorkers) who were trying to claim the Green Mountains for themselves.

Remington's Tavern was a half mile from Castleton's first tavern, a half mile west of the village and six years old by the night of May 8, when Allen and some of his eighty-three men commandeered its taproom. Drunk, hung over or just a combination of the two, they found a slumbering guard to Ticonderoga, and the American militiamen claimed their first victory of the war. (For more background on Remington's and the Stone-Fence, look for cocktail historian David Wondrich's entertaining account in *Esquire* magazine.)

Modern: Good Neighbors

Substituting rye for rum makes this a slightly more savory drink, if not entirely historically accurate. It still packs a punch, though.

1½ ounces rum
2 dashes Angostura bitters
ice
sparkling hard cider

In the bottom of a Collins glass, combine rum and bitters and swirl to combine. Add ice and then top with hard cider.

SWITCHEL AND SHRUB

Ask a Vermont farmer what a typical day of haying is like, and he might sigh that it's hot, long and parching. That sun beats down like a stone from hell while the grain is cut and bundled, and so much sweat pours from his brow that he feels like a raisin in the sun.

Back in the 1700s, cold water was thought to shock the system of someone out in the fields, so more often than not farmers would quench themselves with drinking copious amounts of beer, cider or switchel, a tangy blend of water, ginger, sugar, maple syrup, citrus and vinegar that's quenching on hot days. While the idea of drinking vinegar

The hard work of haying could be allayed by a swig of zesty switchel.

may cause a reflexive nose crinkle, fermented fruit was commonplace in rural New England—especially orchards—and vinegar was in almost every larder. When the drink migrated up from the Caribbean, it gained a foothold in colonial New England.

The vinegar was a double-edged culinary solution. In inland New England, lemons, limes and oranges were not always easy to come by; in their stead, more commonplace vinegar could offer a zing to drinks and a lift for hayers in their hours of need. If they didn't have rum on hand, fresh ginger could mimic its burn.

Switchel also goes by the names sitchel, ginger punch or swizzle, and it has its nutritional secrets. Ginger, vinegar, maple syrup and molasses are all high in potassium. Those invigorating electrolytes probably account for haymakers' instinctive love of the stuff in pre-Gatorade days, as well as its thousand-year-plus popularity—under various guises, blends of vinegar, water and sweetener have cropped up across time and culture. Switchel is similar to the ancient Greek medicinal called oxymel, for instance, a blend of vinegar, honey and water. A sip of switchel can be palate-cleansing, quenching and a surprise to the senses.

Besides modern versions of switchel, "drinking vinegars" are creeping back behind modern bars. One form of these are shrubs, another byproduct of colonial thrift and ingenuity. Shrubs are basically a blend of mashed fruit macerated with sugar and vinegar; they're an ingenious way to capture and bottle a fleeting harvest of berries, currants or other fruit. By mashing fruit together with sugar

and vinegar, and then letting the flavors ferment and blend, it creates a syrupy, sharp drink that could be sipped on its own or combined with water or booze into a proto-cocktail.

With shrubs, a little bit (say, a spoonful) goes a long way; it also stains your drink with jewel tones and lends funky flavors.

Traditional/Modern: Switchel

½ gallon water
1 teaspoon ginger, peeled and minced
½ cup maple syrup (or honey/molasses)
juice from one lemon
¼ cup cider vinegar
¾ cup dark rum (optional)
mint sprigs and slices of lemon to
 garnish

Combine 3 cups of the water with ginger in a small saucepan. Bring to a boil over medium-high heat and boil for 2 minutes. Remove from the heat, cover and let infuse for 15 minutes. Strain the ginger-infused water into a pitcher, pressing on the ginger solids to extract all the liquid. Add maple syrup (or honey/sugar/molasses); stir until dissolved. Stir in lemon juice, vinegar, the remaining six cups water and rum (if using). Chill until cold, at least 2 hours or overnight. Stir the punch and serve in tall glasses over ice cubes. Garnish with mint and slices of lemon.

Several New England companies have revived switchel in recent years. This non-alcoholic version is made in Vermont. *Author photo.*

Traditional: Cherry Shrub (from The Virginia Housewife*)*

Gather ripe morello cherries, pick them from the stalk, and put them in an earthen pot, which must be set into an iron pot of water; make the water boil, but take care that none of it gets into the cherries; when the juice is extracted, pour it into a bag made of tolerably thick cloth, which will permit the juice to pass, but not the pulp of your cherries; sweeten it to your taste, and when it becomes perfectly clear, bottle it— put a gill of brandy into each bottle, before you pour in the juice—cover the corks with rosin. It will keep all summer, in a dry cool place, and is delicious mixed with water.

Shrubs capture and preserve fruit at the height of their brief season. *Author photo.*

Modern: Blackberry Shrub

1 pound blackberries
½ pound sugar
red wine vinegar

Wash berries and then add to a bowl with sugar. Lightly mash the berries into the sugar so they start to release their juices and then set aside overnight in the refrigerator. (If you're bold, leave them out on the counter.)

Press berries through cheesecloth lines into a fine sieve, letting the juices fall. Leave the berries this way for a time to allow all of the juices to ooze out. (You can now use this berry mash on top of some yogurt or ice cream, or compost or discard.) Pour sweetened berry juice into a sanitized Mason jar and add vinegar. Shake to combine and then let rest for at least a day. The shrub will keep for a few weeks inside the refrigerator.

Toddy

For the kinds of New England days that are so cold they freeze off your butt and hand it back to you on a platter, colonial New Englanders had an answer: the toddy. Toddy was served hot and in bowls, and its name is repeated like a mantra on the pages of colonial tavern ledgers of the 1700s. Traditionally, toddy was the combination of rum (or another spirit) with hot water and sugar, although a girding combo of beaten egg yolks, rum and sugar was served in double bowls inside the Wolfe Tavern of Newburyport, Massachusetts, in 1765. At May's Tavern, "boles of tody" cost five shillings in 1766, when they were imbibed by a handful of selectmen who dined there.

Although toddy recipes might vary from tavern to tavern, they were usually stirred with a wooden "toddy stick," a type of muddler also used for crushing spices. Adding a spritz of lemon juice is a relatively modern twist.

Traditional: Hot Toddy

hot water
2 ounces rum or whiskey
½ teaspoon sugar (or more or less to taste)
scrape of nutmeg (optional)

Heat water to boiling in a saucepan or kettle. Measure rum or whiskey into a tall mug. Fill to the top with hot water and spoon in sugar, stirring to blend. Grate some nutmeg on top if desired. Drink hot.

Modern: Hot Buttered (Maple) Rum

A combination of fresh ginger, cardamom and cinnamon makes this hot toddy irresistible on a frigid night. It takes very little fuss, too—the drink comes together in as much time as it takes to boil water. A pat of butter delivers silkiness, and the spices taste as though they are actively

repelling viruses. Using maple rum lends sweetness that allows you to go easy on sugar.

2–3 cardamom pods
1 pat of unsalted butter (cultured butter works especially well)
a few slices of peeled fresh ginger
1 teaspoon of light brown sugar, or more to taste
pinch of orange zest, or an orange twist
pinch of nutmeg
pinch of cinnamon, or a cinnamon stick
1 dram of maple rum, to desired strength
hot water
a few drops of vanilla (optional)

Add cardamom pods to bottom of a tall mug and muddle slightly with a pestle or other blunt kitchen tool. Add butter, ginger, sugar, orange zest and spices. In a separate mug, combine rum and hot water and then pour over spice mixture. Stir to dissolve butter and sugar, add a few drops of vanilla if desired and serve.

WHISTLE-BELLY VENGEANCE

Improperly stored home-brewed beer tends to go sour. For colonial New Englanders, "waste not, want not" was a guiding maxim (still is), and throwing beer away was not an option. In Salem, Massachusetts, colonial barkeeps would mask its flavor in a novel way: simmer it in a kettle, sweeten it with molasses and then drop in crumbles of stale rye or corn bread. Was Whistle-Belly Vengeance breakfast, an after-dinner drink or just a big mistake? For the residents and visitors to Salem in the 1700s, it was a concoction native to their city, although it had its roots in England, where variations were called Whip-Belly and Whistle-Jacket. The writer Jonathan Swift encountered the drink during his travels throughout colonial New England. As he wrote in his *Polite Conversations* of 1731:

Hostess (offering ale to Sir John Linger): I never taste malt-liquor, but they say ours is well-hopp'd.

Sir John: Hopp'd why if it had hopp'd a little further, it would have hopp'd into the river.

Hostess: I was told ours was very strong.

Sir John: Yes! Strong of water. I believe the brewer forgot the malt, or the river was too near him. Faith! It is more whip-belly-vengeance; he that drinks most has the worst share.

Traditional: Whistle-Belly Vengeance

Chances are that you'd rather not drink bits of soggy bread that have been steeped in sour beer. In case you do, though, here's a recipe courtesy of drinks historian Sanborn C. Brown: "Simmer your sour beer in a kettle, and sweeten it with molasses. Drop in crumbles of browned cornbread, and drink 'as hot as could be borne.'"

A NOTE ON MIXERS

A colonial taproom was stocked not only with casks of rum, ale and cider but also an array of sweeteners (molasses and sugar, mostly), emulsifiers (eggs and cream), acids (citrus and vinegar) and spiritous waters made from barks, roots, herbs and fruits. Tavern inventories from Boston and elsewhere from the 1730s on show that "cinnamon water" was a popular mixing agent, as were mint and orange water.

Often, these weren't waters at all. They were spirits infused with the essences of spices, fruit peel and herbs. Nearly three centuries later, we have a vastly broader selection of liquors, syrups and bitters with which to mix our drinks. But we can still hew to the spirit of early American tipplers by grabbing flavors from our gardens, forests and fields. Each season (outside of November through early April) offers up its own bounty—from cherries to rhubarb to rosehips to fresh, bushy spruce tips; even in winter, we can grab the bark of birch trees.

And what do we do with them? Make simple syrup, for one.

SIMPLE SYRUP

This aptly named sweetener is simple to make and distributes itself gracefully and evenly through a cocktail. Just add one part sugar to one part water, heat in a saucepan and stir until dissolved (this usually happens

quickly). Remove from heat, let cool and place in a jar. It will keep for up to three weeks in the refrigerator.

Although not a colonial ingredient per se, simple syrup is a fine substitute for straight sugar and an ideal way to weave in flavors from your garden, farmers' market or woods—a blank slate for almost anything you want to throw at it, from currants to rhubarb to pepper to lemon peel.

I particularly love making tart, vitamin C–rich rosehip simple syrup, especially as rosehips grow abundantly throughout New England. These tart, shiny red fruits build in redness as the summer wanes, reaching the apogee of their flavors after the first frost. A rosehip simple syrup is a colorful and elegant way to bring the landscape into your cocktail. But by no means stop with rosehips—get creative! Anywhere you see sugar or syrup mentioned in a recipe, throw in one of your own.

Modern: Rosehip Simple Syrup

Gather rosehips after the first frost and then trim the fruit; slice in half and remove the seeds. Add to a heatproof bowl and then mash the rosehips slightly with a masher or the end of a rolling pin. Pour over enough boiling water to cover them and let sit for a half hour. Using a cheesecloth, drain juices into a saucepan, pressing and squeezing as you go. Repeat the process: pour more boiling water over the remaining rosehip pulp, let sit and drain/squeeze again. This double infusion neutralizes the tiny hairs on the remaining seeds that can irritate your mouth and throat.

Add as much sugar as you have infused water, then heat until the sugar dissolves. Let cool, bottle and add the syrup to cocktails.

FRESH NUTMEG AND SPICES

Many drinks from the colonial era call for nutmeg, from a sprinkling to a shower. Yet nutmeg was something of a luxury, especially away from the coast. The Dutch had colonized the Banda Islands, where almost

all nutmeg was harvested, and they had a monopoly on the spice. That didn't stem its popularity in drinks and cooking, however, and travelers sometimes carried their own nutmeg in tiny holders, which they could produce to finish the drinks they ordered; house nutmeg was also behind the bar in better-equipped taverns.

When I first began using nutmeg in drinks, I grabbed a months-old bottle in my pantry. However, ground nutmeg quickly loses its edge. The sensual difference between the dust from my crusty old bottle of nutmeg and the shavings from fresh, whole nutmeg (which I easily found in bulk at a local coop) is startling. Do yourself the same favor and score some fresh nutmeg (and a good microplane) for your pantry.

CITRUS

Lemons, limes and oranges had to be imported into the colonies, but regardless of expense, they play an integral role in countless drinks. The preserved juice that squirts from a bottle (or even Rose's Lime Juice) is an affront to all that is good and holy about a cocktail. Always use fresh limes, lemons and oranges when citrus is required.

EGGS

If you're making a drink with eggs and/or cream, use the *very* freshest you can find, from a source you can trust. Raw eggs are risky to consume, although I have yet to ever get sick from sipping a drink make with them.

SPIRITS

I have the good fortune to live in Vermont, where a microdistilling resurgence is well underway, and I have access to excellent, locally produced spirits that echo their colonial forebears. Occasionally I grab a bottle made out of state, but not often, as everything I need is made by friends and acquaintances.

Such as rum. Of course, sugar isn't produced in Vermont, but it didn't originate in Massachusetts or Rhode Island either, back when those

The modern Vermont Spirits distillery in Quechee, Vermont. *Author photo.*

states were producing millions of gallons of rum per year from imported molasses. The modern distillers who have embraced rum are producing some delectable versions tinged with vanilla, oak and caramel notes. You can produce fine (and historically accurate) drinks with Mount Gay or Bacardi Gold rums, but as availability and budget allow, seek out one of the rums made in your own state. If you live in New England, there will be several to choose from. For me, both Smuggler's Notch Distillery Rum and Dunc's Mill Maple Rum are mainstays.

The same ethos holds for whiskey. Today, we're accustomed to sipping copper-hued whiskey that's been barrel-aged. Yet when whiskey first comes off the still, it's colorless, clear and a little bit sweet. This was the kind of whiskey imbibed just after the Revolution, the kind that poured from the dented stills on Pennsylvania farms. White whiskey may have the term "moonshine" attached to it, for better or worse, but it's much more than that—a beguiling spirit that you can use in place of vodka, and one with more warmth and character.

GLOSSARY

acerglyn: Wine made from maple syrup; a type of mead.

apple brandy: Distilled hard cider that has been aged in barrels. Also called eau de vie.

applejack: Hard cider that has been distilled into a spirit via fractional distillation; in colonial New England, it was created by leaving cider outside to freeze, concentrating its alcohol content.

Bellow-Stop: A flip into which beaten eggs were blended.

beverige: A non-alcoholic drink of sugar or molasses mixed with water and ginger.

bitters: Alcohol infused with herbs, bark or fruit peels, especially orange peel and gentian. In colonial America, "taking bitters" was a morning ritual. Bitters didn't become a cocktail ingredient until the late 1800s. Angostura bitters were one of the earliest commercial bitters that are still in use today.

Bombo: A Mimbo (dark rum, brown sugar and water over ice) that has had nutmeg shaved over the top.

bracer: A drink to clear the mind.

braggot: Mead blended with ale and spices.

brandy: The distilled spirit of fermented fruit juice, whether from apples, grapes, pears or other fruit. Brandy was one of the first distilled spirits and was closely aligned with France and Spain for centuries.

Calibogus: A drink of spruce beer, molasses and a splash of rum, served either hot or cold.

cherry bounce: Brandy (or any brown spirit) infused with cherries and sugar.

cider: The juice of pressed apples. Letting apple juice ferment yields hard cider, a staple colonial New England drink that was imbibed continuously at home, in the fields and in the tavern.

ciderkin: A lower-alcohol version of cider made from the second pressing of apples, primarily drunk by colonial-era children.

cider royal: Distilled cider blended with apple brandy or whiskey.

cobbler: The blend of a base spirit such as rum with citrus juice, sugar and spices. Cobblers took advantage of a relatively new discovery in the nineteenth century, ice, and didn't rise to prominence until the early 1800s.

cooler: Any refreshing beverage.

cooper: A crafter of barrels, especially for beer and spirits.

cup: A colonial term for a drink of wine, spirits, fruit juices and soda that is served from a pitcher.

ebulum: An ale flavored with elderberry and/or juniper and other herb or fruit juices.

flip: A mixed drink that typically consisted of strong beer, a splash of rum, molasses, spices and occasionally eggs or cream. The drink was whipped into a froth by plunging a red-hot poker into its midst.

gin: An aromatic white spirit distilled from grains and always spiced with juniper berries. The spirit began its life in Belgium as genever, and due to its low cost, overconsumption of gin became a scourge of seventeenth-century British cities. It never had much of a presence in the colonies.

grog: A blend of rum, sugar, lime and water that was born in the British navy as they cut rum with water to stretch it further. This immensely popular colonial drink, usually served cold, was typically served in colonial bars called grogshops.

hogshead: A large wooden cask that was used to transport liquids such as wine, ale and molasses. In colonial times, a hogshead held about three hundred liters.

Hotch-Pot: A blend of warm beer with rum.

Madeira: A fortified, oxidized grape wine that became a common, patriotic drink in colonial America, owing to its direct shipment from the Portuguese island of Madeira to the colonies. Its flavors are typically luscious, nutty and rich.

mamm: A blend of water, sugar and rum; more common on the frontier than in New England.

mead: A fermented honey drink.

meridian: A blend of brandy and tea.

metheglin: Mead that has had spices added.

Mimbo: A blend of dark rum, brown sugar and a splash of water over ice.

mumm: An ale brewed from wheat and oat malt.

nip: Less than one half pint of liquor.

perry: The pressed, fermented juice of pears.

posset: A hot drink that originated in England and consisted of boiling milk blended with either sack, beer, ale or wine and spices. The curdled result resembles custard or eggnog.

punch: Typically a blend of rum or brandy (or both), sugar, spices and water, served communally from a large bowl. Punch originated in India and was carried via trade routes to the Caribbean—where it became entrenched—and later to the colonies.

quartern: Quarter of a gill, or a dash.

Ratafia: A cordial of brandy or wine spiced with lemon peel, herbs and sometimes cherry or peach kernels or nuts, as well as sugar. Although it's of Mediterranean origin, scrappy colonial residents might have used sour or black cherries, juniper berries and even coffee beans to flavor their Ratafia.

Rattle-Skull: A potent blend of dark beer such as porter with shots of rum and sherry added, plus a spritz of lime juice and a sprinkle of nutmeg, served in a pint glass.

sack: The colonial name for sherry, a wine made in the Jerez region of Spain, in Andalusia. Palomino grapes are fermented and then aged in casks before they are fortified with brandy.

sangaree: This precursor to modern sangria was born in the West Indies during the late 1700s and featured a blend of rum, brandy, port or red wine with spices, citrus and fruit.

settler: An after-meal drink that would calm the stomach; the colonial equivalent of a digestive.

shrub: A refreshing blend of vinegar, fruit juices and sometimes spirits that was commonly sipped at home, either on its own or combined with spirits.

simple syrup: A liquid sweetener made by combining equal parts sugar and water and heating until the sugar dissolves.

sling: A two-to-one blend of water and spirit (often rum or brandy) with a touch of sugar and citrus.

spruce beer: A strong beer brewed with molasses and the tips of white spruce trees.

stiffener: A drink to build one's fortitude.

Stone-Fence: A colonial-era mixed drink of hard cider and rum that Ethan Allen's Green Mountain Boys allegedly imbibed the night before storming the British at Fort Ticonderoga during the Revolutionary War.

switchel: A zingy drink whose key ingredient is vinegar, layered with citrus, ginger, rum and sometimes honey, syrup or molasses. Switchel was sipped in rural New England during haying as a way to stay refreshed in the fields. Non-alcoholic switchel is identical but for the rum.

syllabub: A drink originally created in England by herders milking cows straight into a bowl of ale or cider. The syllabub consumed by colonial Americans was a blend of heavy cream, spices such as nutmeg and either ale or spirits.

tankard: A one-handled drinking mug of the 1600s and 1700s. Tankards were ceramic, wooden or forged from pewter or silver. In colonial New England, they were the vessel of choice for drinking beer and cider. Pewter tankards and acidic drinks such as cider weren't always a healthy marriage; the acids in cider could leach lead from the metal, poisoning the drinker.

toddy: A hot drink of rum, citrus, molasses and water. A pat of butter can be added for a hot buttered toddy, sometimes called hot buttered rum. Modern toddies often draw on whiskey instead of rum.

vermouth: A powerful wine distillate that has been fortified with brandy.

wassail: A hot punch usually drunk in the autumn and often made from ale, Madeira and hard cider laced with spices such as nutmeg and allspice.

whetter: A drink to induce appetite; the colonial equivalent of an aperitif.

whiskey: A spirit distilled from corn, rye or sometimes other grains. It rose to prominence in America after the Revolution, but its roots lie in the 1700s. Corn grew exceedingly well in America, and after the war, corn whiskey (and moonshine) became the preferred national spirit.

Whistle-Belly Vengeance: A drink consisting of sour beer, molasses and rye bread crumbs, served hot. It was on the bill of fare at the Buckman Tavern in Lexington, Massachusetts, around the time of the American Revolution.

ACKNOWLEDGEMENTS

*T*he generosity of fellow authors, researchers and friends—some of whom I've never met—made this little work possible. The passionate librarians of the Vermont Historical Society, Marjorie Strong and Paul Carnahan, are tireless when it comes to finding buried bits of information. Although I visited several historical societies over the three-month span of writing this book, they were the gems of the bunch.

Also, thanks to Barbara Kreiger of the Rauner Library at Dartmouth College, who connected me with the amusing letters from Eleazor Wheelock (Dartmouth's first president) to then New Hampshire governor Wentworth. Culinary historian Jeff Roberts was tremendously helpful in connecting me with other brains I needed to tap, including Roger Albee, former secretary of agriculture for the State of Vermont and a font of knowledge about Vermont's early forays into potato whiskey and apple brandy.

Ben Watson's book *Cider: Hard & Sweet* is a cornerstone of the current cider revival, and I'm thankful for his insights into cider's role in American history.

I didn't talk much about this book while at work, but I'm sure my co-workers and bosses at *Seven Days* sensed that I was more scattered than usual for a four-month period. I'm grateful for their patience.

I'm also indebted to the researchers and writers who have explored this subject before me: J.J. Rorabaugh, Sanborn C. Brown, Gavin

Nathan, John Wriston, Andrew Smith, David Wondrich, Andrew Barr, Eric Burns and especially the long-gone Alicia Morse Earle. Their works were infinitely more meticulous than mine could ever be, given time and scope, and without their glorious obsessions, this book would not have come to be.

Thanks to The History Press for giving me the opportunity to write this book, as well as to my project editor, Ryan Finn, for lending his sharp eye to the manuscript.

Lastly, the support of friends and family is the invisible scaffolding behind these words. Thanks to Mary Haring, Maryellen Apelquist, Helen Clark, Tandy Culpepper and George Hirsch for their encouragement as well as grace in listening to me ramble about colonial drinking ephemera. Thanks especially to Arthur Riscen for his generosity, patience and well-timed deliveries of food and humor.

SOURCES

*A*s I mentioned earlier, I'm hugely indebted to other food and drink historians, writers and authors who have cut trails in drinks history before me. Three books proved to be especially invaluable, and two were penned by Browns. The first, *Early American Beverages*, was written by John Hull Brown in 1966 and published in Rutland, Vermont, by the Charles B. Tuttle Company. I'm not quite sure where Brown tracked down all of the information that he stuffed into this 171-page book, but his exhaustive bibliography speaks to years of intense research and the verve of a true drinks geek before such a thing even existed.

The other, *Wines & Beers of Old New England: A How-to-Do-It History* by Sanborn Brown, is dense with resurrected drinks of early America, from "sillabub" to malt-birch beer. Brown offers detailed instructions on how to make one's own cider, beer and wine, resulting from Brown's "long years of experimentation." We're all richer for it.

Any student of drinking should be forever grateful to historian W.J. Rorabaugh, whose thorough, precise research for *The Alcoholic Republic: An American Tradition* is a deep font of insight into colonial drinking habits. Rorabaugh was obsessive enough to organize his data into text charts, generating hierarchies of drinking patterns over time and drinking customs among different social groups at various times in our history.

Acrelius, Israel. *History of New Sweden, Or, The Settlements on the River Delaware, Drinks Used in North America.* Philadelphia: Publication Fund of the Historical Society of Pennsylvania, 1874.

Adams, John. *Diary and Autobiography of John Adams.* Vols. 1–4. Cambridge, MA: Belknap Press of Harvard University Press, 1961.

Bailey, L.H. *Sketch of the Evolution of Our Native Fruits.* New York: Macmillan Company, 1898.

Barr, Andrew. *Drink: A Social History of America.* New York: Carroll & Graf Publishers Inc., 2000.

Bogart, Ernest. *Peacham: The Story of a Vermont Hill Town.* Barre: Vermont Historical Society, 1948.

Bowles, Ella Shannon. *Secrets of New England Cooking.* Mineola, NY: Dover Publications, 2000.

Bradford, William. *Of Plymouth Plantation.* New York: Charles Scribner's Sons, 1908.

Brown, Sanborn C. *Wines & Beers of Old New England: A How-to-Do-It-History.* Hanover, NH: University Press of New England, 1978. *Note*: This book is a treasure chest of beer and wine recipes from the days of yore. Mr. Brown seemingly pored over old cookbooks, family recipes and historical documents to assemble this motley collection of thorough how-tos and taste guides, and I'm grateful for his work.

Burns, Eric. *The Spirits of America: A Social History of Alcohol.* Philadelphia: Temple University Press, 2004.

Clapp, Roger. *The Memoir of Capt. Roger Clapp of Dorchester.* N.p., circa 1640. Accessed at the website of the Winthrop Society, www.winthropsociety.com.

Coburn, Frank Warren. *The Battle of April 19, 1775, in Lexington, Concord, Lincoln, Arlington, Cambridge, Somerville and Charlestown, Massachusetts.* Lexington, MA: Lexington Historical Society, 1922.

Conroy, David. *In Public Houses: Drink & the Revolution of Authority in Colonial Massachusetts.* Chapel Hill: University of North Carolina Press for the Institute of Early American History and Culture in Williamsburg, Virginia, 1995.

Coulombe, Charles. *Rum: The Epic Story of the Drink that Conquered the World.* New York: Citadel Press, 2005.

Crawford, Mary Caroline. *Little Pilgrimages Among Old New England Inns, Being an Account of Little Journeys to Various Quaint Inns and*

Hostelries of Colonial New England. Boston: Page & Company, 1907. *Note*: Crawford was clearly enraptured by history. As she wrote in her foreword, "A book on old New England Inns needs no elaborate justification. Few of us are so dull of soul that our pulses are not quickened and our imaginations stirred as we pass, at a country four-corners, a deserted house and rambling barn of unmistakable tavern descent. There it stands, in its sombre and often disreputable coat of weather-stained shingles, mournful reminder of a fragrant time that is now no more, mute witness to the truth of the familiar plaint that bygone days were—what these are not. Always one is eager to know the story of such a house and to repeople its empty rooms, in fancy at least, with those who once made merry there."

Cronon, William. *Changes in the Land: Indians, Colonists, and the Ecology of New England*. New York: Hill and Wang, 1983.

Dabney, Joseph Earl. *The Food, Folklore, and Art of Lowcountry Cooking*. Naperville, IL: Cumberland House/Sourcebooks, 2010.

Earle, Alicia Morse. *Stage-Coach and Tavern Days*. New York: Macmillan Company, 1900. *Note*: I wish I could jump into a time machine to chat with Alicia Morse Earle over a pint. The precision and breadth with which she approached her research is awing.

Eastman, John R. *History of the Town of Andover, New Hampshire, 1751–1906*. Concord, NH: Rumford Printing Company, 1910.

Field, Edward. *The Colonial Tavern: A Glimpse of New England Town Life in the 17ᵗʰ and 18ᵗʰ Centuries*. Providence, RI: Preston Rounds, 1897.

Franklin, Benjamin, and Albert Henry Smyth. *The Autobiography of Benjamin Franklin*. Vol. 10. Project Gutenberg e-book release, 2006.

Garvin, Donna-Belle, and James L. Garvin. *On the Road North of Boston: New Hampshire Taverns and Turnpikes, 1700–1900*. Hanover, NH: University Press of New England, 1988.

Geake, Robert A. *Historic Taverns of Rhode Island*. Charleston, SC: The History Press, 2012.

Grimes, William. *Straight Up or On the Rocks: The Story of the American Cocktail*. New York: North Point Press, 2002.

Hines, Mary Anne, Gordon Marshall and William Woys Weaver. *The Larder Invaded: Reflections on Three Centuries of Philadelphia Food and Drink: A Joint Exhibition Held 17 November 1986 to 25 April 1987*. Philadelphia: Historical Society of Pennsylvania, 1987.

Hinman, Timothy. *General Store Daybook, 1761–1850*. Accessed at Vermont Historical Society.

Huntoon, Daniel T.V. *History of the Town of Canton, Massachusetts.* Cambridge, MA: J. Wilson & Son, 1893.

Kimball, Gertrude Selwyn. *Providence in Colonial Times.* Boston: Houghton Mifflin Company, 1912.

Larkin, Jack. *The Reshaping of Everyday Life, 1790–1840.* New York: Harper & Row, 1988.

Lichin, Alexis. *New Encyclopedia of Wines & Spirits.* New York: Alfred A. Knopf, 1977.

MacKenzie, Colin. *Mackenzie's Five Thousand Receipts in All the Useful and Domestic Arts: Constituting a Complete Practical Library Relative to Agriculture, Bees, Bleaching etc.* Pittsburgh, PA: James I. Kay & Company, 1831. Accessed online via Google eBooks.

Mariani, John. *America Eats Out: An Illustrated History of Restaurants, Taverns, Coffee Shops, Speakeasies and Other Establishments that Have Fed Us for 350 Years.* New York: William Morrow & Company, 1991.

McCusker, John. *Rum and the American Revolution: The Rum Trade and the Balance of Payments of the Thirteen Continental Colonies.* 2 vols. New York: Garland, 1989.

Mendelson, Richard. *From Demon to Darling: A Legal History of Wine in America.* Berkeley: University of California Press, 2009.

Mittleman, Amy. *Brewing Battles: A History of American Beer.* New York: Algora Publishing, 2007.

Morewood, Samuel. *An Essay on the Inventions and Customs of Both Ancients and Moderns in the Use of Inebriating Liquors: Interspersed with Interesting Anecdotes, Illustrative of the Manners and Habits of the Principal Nations of the World. With an Historical View of the Extent and Practices of Distillation.* London: Longman, Hurst, Rees, Orme, Brown and Green, 1824.

Moxon, Elizabeth. *English Housewifry.* N.p., 1764. Republished by Bibliolife, 2008.

Nathan, Gavin. *Historic Taverns of Boston: 370 Years of Tavern History in One Definitive Guide.* Bloomington, IN: iUniverse, 2006.

Pattee, William Samuel. *A History of Old Braintree and Quincy: With a Sketch of Randolph and Holbrook.* Ithaca, NY: Cornell University Library, 2010.

Pert, George H. *On the History of Inns, Taverns and Hotels in Hanover, N.H.* Hanover, NH: Dartmouth College, 1944.

Pinney, Thomas. *A History of Wine in America: From the Beginnings to Prohibition.* Berkeley: University of California Press, 1989.

Randolph, Mary. *The Virginia Housewife.* N.p., 1824. *Note*: First published in 1824, this compendium was published years after the colonies had disappeared but contains a wealth of recipes whose roots stretch back to colonial America.

Rice, Kym S. *Early American Taverns: For the Entertainment of Friends and Strangers.* For the Fraunces Tavern Museum. Chicago: Regnery Gateway, 1983.

Rorabaugh, W.J. *The Alcoholic Republic: An American Tradition.* New York: Oxford University Press, 1979.

Salinger, Sharon V. *Taverns and Drinking in Early America.* Baltimore, MD: Johns Hopkins University Press, 2002.

Schoelwer, Susan P., ed. *Lions and Eagles and Bulls: Early American Tavern and Inn Signs.* Hartford: Connecticut Historical Society, 2000.

Smith, Andrew F. *Drinking History: Fifteen Turning Points in the Making of American Beverages.* New York: Columbia University Press, 2013.

Smith, Eliza. *The Compleat Housewife.* Williamsburg, VA: William Parks, 1742.

Standage, Tom. *A History of the World in 6 Glasses.* New York: Walker & Company, 2005.

Tavern Records of Captain Isaac March from Stockbridge, Mass. N.p., 1788.

Thompson, Peter. *Rum Punch & Revolution: Taverngoing & Public Life in Eighteenth-Century Philadelphia.* Philadelphia: University of Pennsylvania Press, 1999.

Thomun, Gallus. *Colonial Liquor Laws.* Part II. *Of "Liquor Laws of the United States and Their Spirit and Effect."* N.p.: United States Brewers' Association, 1898.

Washington, George. *Notebook as a Virginia Colonel, 1757.* New York: New York Public Library, Manuscripts and Archives Division.

Waters, Thomas Franklin. *Ipswich in the Massachusetts Bay Colony.* Vol. 2. *A History of the Town from 1700 to 1917.* Ipswich, MA: Ipswich Historical Society, 1917.

Watson, Benjamin. *Cider Hard & Sweet: History, Traditions, and Making Your Own.* Woodstock, VT: Countryman Press, 1999.

Weir, Silas Mitchell. *A Madeira Party.* New York: Century Company, 1895. *Note*: Although this whimsical story was published more than a century after the Revolution, it fleshes out the passions and rituals surrounding

the drinking of Madeira at a dinner party of "terrapin and cigars" held by three old men. The story is filled with such gems as, "I have noticed that the acquisition of a taste for Madeira in middle life is quite fatal to common people," and, "I, myself, think the finest of the old dry Madeiras were once sugary maidens."

Whistler, Henry. *Journal of the West India Expedition.* N.p., 1654–55. Available from the British Museum.

Williams, Ian. *Rum: A Social and Sociable History of the Real Spirit of 1776.* New York: Nation Books, 2006.

Wine Account for the General Assembly of 1787. Available at the Vermont Historical Society.

Winslow, George. *Mourt's Relation: A Journal of the Pilgrims at Plymouth, 1622.* Part I. Accessible online at http://www.histarch.illinois.edu/plymouth/mourt1.html.

Wriston, John. *Vermont Inns & Taverns: Pre-Revolution to 1925, an Illustrated & Annotated Checklist.* Rutland, VT: Academy Books, Rutland, 1991.

Articles and Papers

Apple, R.W., Jr. "A Southern Star Rises in the Lowcountry." *New York Times*, March 15, 2006.

Carmichael, Zachary Andrew. "Fit Men: New England and Tavern Keepers, 1620–1720." Master's thesis, Miami University Department of History, 2009.

"Deleterious Effects of Distilled Spirits on the Human System. Communicated to the Senate, December 29, 1790." Address by the College of Physicians of Pennsylvania. Accessed online at books.google.com.

Geiling, Natasha. "What Caused the Death of American Brewing?" Smithsonian Food + Think blog, August 1, 2013.

Letters between Eleazor Wheelock and Governor John Wentworth, 1774–1775. Collection of the Rauner Library at Dartmouth College.

Mather, Cotton. "Sober Considerations on a Growing Flood of Iniquity, Or, an Essay to Dry Up a Fountain of Confusion and Every Evil Work, and to Warn People Particularly of the Woful Consequences Which the Prevailing Abuse of Rum Will Be Attended Withal." Printed by John Allen in Pudding-Lane for Nicholas Boone at the Sign of the Bible in Corn-hill, near the corner of School-Street, 1708.

North, Jesse Natha. "Set the Table with Switchel." *Local Banquet* (March 1, 2010).

Parker, Robert J. "Thomas Oliver Larkin in 1831: Letter from North Carolina." *California Historical Society Quarterly* 16, no. 3 (September 1937): 263–70.

Risen, Clay. "Back in the Mix: New England Rum." *New York Times*, October 20, 2012.

Sinnott, Roger W. "Astronomical Computing." *Sky & Telescope*, April 1992.

Tuten, James. "Have Some Madeira, M'Dear: The Unique History of Madeira Wine and Its Consumption in the Atlantic World." Bookend seminar, April 2, 2008.

Vaughan, Samuel. *Samuel Vaughan's Journal, or "Minutes Made by S.V., from Stage to Stage, on a Tour to Fort Pitt."* Edited by Edward G. Williams. From *Pennsylvania History*, accessed online at Open Journal Systems.

Wondrich, David. "How the Sling Was Slung." *Imbibe* (July/August 2011).

Web

Anchor Steam Brewing. "Small Beer, Big Flavor." Anchorbrewing.com.

Food Timeline. "Colonial American Tavern Fare." http://foodtimeline. org/foodcolonial.html#tavernfare.

LaBan, Craig. "Madeira Making a Comeback, with a Bit of Help from Ben Frankin." Philly.com, April 28, 2011.

Lear, Jane. "Obsession: Peach Ratafia." Janelear.com.

MadeiraWineGuide.com.

Theobald, Mary Miley. "When Whiskey Was the King of Drink." History.org. http://www.history.org/foundation/journal/summer08/ whiskey.cfm.

Wondrich, David. "Stone Fence." *Esquire.* http://www.esquire.com/ drinks/stone-fence-drink-recipe.

INDEX

ABOUT THE AUTHOR

*C*orin Hirsch is an award-winning food and drinks writer at *Seven Days*, the alt-weekly in Burlington, Vermont. She learned to pull a pint of Schlitz (for her grandfather) at the age of six, and she used to tend bar inside a sixteenth-century English pub. She has written about craft beer for *Serious Eats* and also ghost-blogs and writes in the wine world. This is her first book.

Visit us at
www.historypress.net

This title is also available as an e-book

www.ingramcontent.com/pod-product-compliance
Lightning Source LLC
Chambersburg PA
CBHW070342100426
42812CB00005B/1403